NEW JERSEY
ORIGINALS

NEW JERSEY
ORIGINALS

Technological Marvels, Odd Inventions,
Trailblazing Characters & More

LINDA J. BARTH

THE
History
PRESS

Published by The History Press
Charleston, SC
www.historypress.com

First published 2018

Manufactured in the United States

ISBN 9781467139267

Library of Congress Control Number: 2018938114

To my friends, who have supported me throughout my writing career.
To my husband, who is always there with his love and support.

CONTENTS

ACKNOWLEDGEMENTS

The author owes many thanks to Melissa Ziobro, Monmouth University; Susan Thompson, CIV USARMY CECOM; Fred Carl, director of the InfoAge Museum; Kyle Hart, Rutgers School of Environmental and Biological Sciences; Margaret Sullivan; Joseph Bilby, the National Guard Museum of New Jersey; Timothy Hart, Tuckerton Seaport; John Kerry Dyke, Perth Amboy historian; Jason Freidenfelds; Henry Kuhl and Mike Vella, Kuhl Corporation; Leonard deGraaf, Thomas Edison National Historical Park; Paul Israel, Edison Papers Project; James Lewis, the Morristown and Morris Township Library; Lynn Burtis, Holcombe-Jimison Farmstead; Dr. Chee-Kok Chin, Department of Plant Biology, Rutgers; Hunterdon 300th Committee; Edison and Ford Winter Estates, Fort Myers, Florida; Lambertville Historical Society; Mark Stewart, Twin Lights Historical Society; Julie Hain, Tuckerton Seaport; Jeff McVey; Adele V.W. Floyd; Linda Hess, historic interpreter, Indian King Tavern Museum; Doug McCray; Leon Segal, director of licensing, Rutgers University, Office of Research Commercialization; Jessie Havens, Somerset County historian; Robert Barth, photography and editing; Ann Smith, Franklin Township Library; Gwen Meade, Margate Public Library; Karen Ayoub, a member of Traposquitoes; Mark Ehlenfeldt, USDA-ARS, research geneticist, P.E. Marucci Center for Blueberry & Cranberry Research; Joe Darlington, Whitesbog; Russell Borus, soap bubble machine; Scott Tiffney, American Philatelic Research Library; David Rogers, Westfield; Martin Kane, Lake Hopatcong Historical Museum; Christine Retz; and Jan and David Wiley.

INTRODUCTION

What makes New Jersey so special? According to Randy Bergmann of the *Asbury Park Press*, lots of things. In his article "Ten Things N.J. Does Better than Other States," Bergmann included culture, wonderful suburban towns, a high standard of living, strong public schools, a mild climate, mountains and beaches and the fact that the Garden State is the gateway to the world.

He and I agree on those points and on one more: innovation. In addition to the creations of Bell Labs and Thomas Edison, New Jersey has innovators and inventors galore. In my first volume, *A History of Inventing in New Jersey: From Thomas Edison to the Ice Cream Cone*, I detailed our state's many inventions in science, communications, food, medicine, sports and transportation.

In this book, you can learn about more of the inventions of Bell Labs and Edison, in addition to other valuable, brilliant and quirky creations. And just for fun, I've added some famous and not-so-famous New Jersey firsts and people.

So kick off your shoes, pour a cup of tea and join me on a Jersey journey of innovation.

1

DOWN ON THE FARM

INTRODUCTION: THE ROLE OF COOK COLLEGE

The George H. Cook Campus, home to the School of Environmental and Biological Sciences and the New Jersey Agricultural Experiment Station (NJAES), is named for George H. Cook, a celebrated nineteenth-century scientist and educator and the first head of the Rutgers Scientific School. Cook College celebrated its thirtieth year in 2003.

In 1864, Rutgers College was named a land-grant college with departments in agriculture, engineering and chemistry. Rutgers had been in competition with Princeton and the state normal school at Trenton, and George H. Cook led the fight to have Rutgers named as the land-grant college.

In the same year, George H. Cook was promoted to state geologist, and the land-grant college was renamed the Rutgers Scientific School. Rutgers College bought ninety-eight acres of land just outside New Brunswick for use as an experimental farm.

In 1880, the State of New Jersey Agricultural Experiment Station was formed; Van Nest Hall became the first headquarters of the state experiment station. Seven years later, Congress passed the Hatch Act, establishing federal agricultural experiment stations at land-grant schools.

The first experimental station laboratory building, New Jersey Hall, opened in 1889, the year George Cook died.

In 1906, the Round House, a stock-judging pavilion built near College Pond (now Passion Puddle), was completed. In 1923, it was moved to its present location on College Farm Road. Six years later, the Cook family

farm on Ryders Lane was purchased, and a fireproof horse barn was built on College Farm.

The Smith-Lever Act of 1914 established the Cooperative Extension Service at each land-grant institution. In 1917, the state legislature designated the Rutgers Scientific School as the State University of New Jersey. Four years later, the trustees formally created the College of Agriculture and established a board of managers to oversee operations. Rutgers College assumed the name Rutgers University in 1924, but the College of Agriculture remained a distinct unit.

Over the decades, many agricultural innovations have come from Cook College. Its professors and scientists have won awards and have been inducted into the New Jersey Inventors Hall of Fame. Today known as the School of Environmental and Biological Sciences (SEBS), the institution continues its research and innovation.

THE RUTGERS TOMATO

The original Rutgers tomato was introduced in 1934 by Rutgers vegetable breeder Lyman Schermerhorn as a general-use tomato. It was good for canning and juicing, as well as the fresh market. At that time, more than thirty-six thousand acres of tomatoes were grown in the Garden State. The original cross was made at the Campbell Soup Company in 1928, with leading processing tomatoes as the parent varieties. In cooperation with Campbell's, Schermerhorn selected the best plants from the cross, and for the next six years, he conducted field tests on New Jersey farms and made further selections until, in 1934, the most superior selection was released as the Rutgers tomato.

The Rutgers tomato had a combination of appealing qualities derived from parents in the Campbell's cross: J.T.D. (named for John T. Dorrance, the innovator behind Campbell's condensed soups) and Marglobe (a leading variety developed at the USDA). It ripened from the inside out—starting at the center—so that when the fruit was red on the outside, it would be colored throughout.

Because this original Rutgers tomato was more resistant to cracking, it became the main ingredient in the Campbell's' soup product line.

The breeding objectives resulted in an amazing array of improved attributes, including:

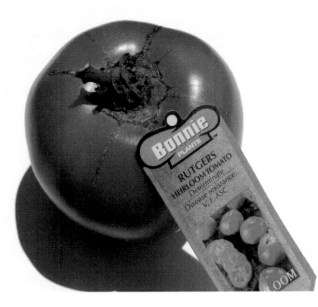

This Rutgers tomato was grown by Margaret Sullivan of Somerville, New Jersey. *Courtesy of Robert H. Barth.*

- pleasing flavor and taste of the juice
- more uniform sparkling-red internal color, ripening from center of the tomato outward
- smooth skin
- freedom from fruit cracking
- early maturity
- handsome flattened globe shape
- vigorous healthy foliage to ripen more fruit and reduce sunscald
- firm, thick, fleshy fruit walls for its time, though considered extremely soft by today's definition of tomato firmness
- uniformity true to type in the field

While the Rutgers tomato is no longer commercially grown for canned tomato production, it is still a favorite among home gardeners and widely available from seed catalogues and garden centers.

For the university's 250th anniversary, the historic Rutgers tomato was reinvented. In 2010, the present-day vegetable researchers at Rutgers sought to re-create the original strain. Rutgers professor of plant breeding Tom Orton; Pete Nitzsche, agricultural agent of Rutgers Cooperative Extension of Morris County; and Jack Rabin, associate director of NJAES farm programs, worked on a research project with Campbell's Soup. Learning that the company still had original seeds in a vault, the team began an extensive

project to re-create the original Rutgers tomato. The summer of 2015 had the finalists narrowed down to three, and after conducting several consumer taste tests in various parts of New Jersey, the final selection was chosen.

The timing of the release of this "retro" Rutgers tomato was serendipitous, as its debut in spring of 2016 coincided with Rutgers' 250th anniversary. Thus, the reinvented Rutgers tomato was dubbed the Rutgers 250 tomato.

A MORE COLORFUL CRANBERRY

Rutgers developed the Haines variety of cranberry—named for William Haines Sr., a Burlington County farmer. This variety is able to withstand disease and has a larger, round berry with more color than other breeds.

The cranberry has been released to farmers and was harvested in 2017, according to Nicholi Vorsa, director of the Philip E. Marucci Center for Blueberry and Cranberry Research and Extension in Chatsworth.

Rutgers researchers continually experiment to create new varieties of cranberries to address the challenges facing the industry, such as changes in farming regulations, the environment and consumer taste.

"If we can increase the resistance in the crop, growers would have to rely less on pesticide," Vorsa noted.

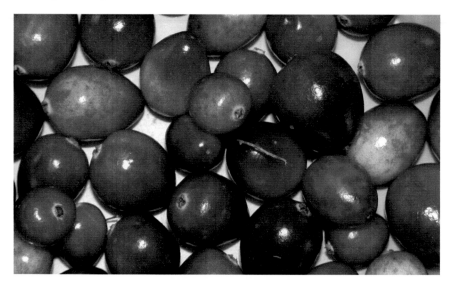

The Haines cranberry is a newly developed strain from Rutgers University. *Courtesy of Peter V. Oudemans, Department of Plant Biology, Rutgers University.*

RUTGERS LETTUCE: PROFESSOR ILYA RASKIN

The Rutgers team has created a new, colorful and nutritionally powerful red leaf plant that they named Rutgers Scarlet Lettuce. With more antioxidants than blueberries, the new lettuce ranks among superfoods that are packed with nutritional value. It's also loaded with fiber and low in calories. Plus, it tastes good.

Professor Ilya Raskin and his team, with support from the National Institutes of Health, wanted to see how they could boost the health value of lettuce through nutritional breeding. They chose lettuce because it is one of the most commonly consumed vegetables in domestic diets. Lettuce gave the team the chance to make a dramatic improvement, as the type that Americans most commonly eat has small amounts of antioxidants.

The Rutgers team also wanted to determine if the nutritional benefits added up. In a study using mice that had been fed a high-fat diet, the researchers found that mice given daily servings of Rutgers Scarlet had reduced blood sugar levels and improved insulin sensitivity.

Coastline Family Farms of Salinas, California, now markets the Rutgers lettuce under the name Nutraleaf.

PUMPKIN HABANERO PEPPER: ALBERT AYENI

The new Rutgers pumpkin habanero pepper is named for its appearance, not its taste. It's hotter than the hottest jalapeño, but mild compared to the fieriest habaneros.

This is the first new variety released through the exotic pepper breeding program, formed to create new products that farmers could grow to appeal to ethnic communities.

The pumpkin pepper measures 30,000 to 50,000 heat units on the Scoville scale, on which habaneros usually fall in the 30,000 to 350,000 range.

IMPROVED STRAINS OF DOGWOOD:
ELWIN ORTON AND TOM MOLNAR

Dr. Elwin Orton of Millstone, New Jersey, is one of many Rutgers professors inducted into the New Jersey Inventors Hall of Fame.

He has been credited with saving the U.S. dogwood industry by developing new strains of hardy, disease-resistant, hybrid dogwoods. In the 1970s, two invaders threatened the native species of the flowering tree. Dogwood anthracnose causes brown spots on the leaves and tree-killing cankers in the twigs and stems. Powdery mildew covers the leaves in a white fungus. "The leaves twist up and basically look very ugly," said Tom Molnar, who oversees the ornamental tree breeding program at Rutgers.

Dr. Orton created thousands of varieties of dogwoods, often crossing the native dogwood with an Asian species, *Cornus kousa*, which is more resistant to disease. One of his many successes was the production of the Stellar Pink, hardier than the native dogwood with pale pink leaves that turn white in the heat. He also developed the Constellation, Celestial and Aurora varieties.

Following in his mentor's footsteps, Tom Molnar planted 1,500 trees from 2007 through 2009, but he found nothing dramatic enough to take to the landscape industry. Dogwoods take four years to grow before blooming for the first time, so patience is necessary. Then, in 2012, while walking in a field that had been planted four years before, Tom was amazed to see a tree glowing pink. Using this as the mother tree, he grew more saplings and was

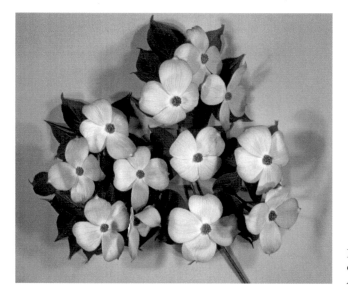

Rutgers Stellar Pink dogwood. *Courtesy of Dr. Elwin Orton.*

rewarded to see the new variety, Scarlet Fire. Named for the school color, it is now available from nurseries.

Dr. Orton, now retired from the university, received more than fifteen patents for new cultivars, strains of dogwoods and holly. Rutgers estimates that the retail value of his creations is greater than $200 million, and licensing royalty proceeds to Rutgers exceed $1.9 million.

Orton has received an award from the American Horticultural Society and the Distinguished Service Medal from the Garden Club of America. He was inducted into the New Jersey Nursery and Landscape Association's Hall of Fame and received the Norman J. Coleman Award of the American Association of Nurserymen. Most recently, the Eastern Region of the International Plant Propagators' Society initiated a new research fund in his honor.

To what does Professor Orton attribute his success in this field? "Good note-taking skills and patience," he said. "Sometimes it can take five, ten, or twenty years to see the characteristics of hybrids."

RUTGERS HAZELNUTS (FILBERTS)

Rutgers began hazelnut research and breeding in 1996. Working with researchers at Oregon State University, Rutgers scientists have developed adapted and productive plants that are highly resistant to Eastern Filbert Blight, a fungal disease that causes stem cankers, branch die-back and eventual death of susceptible hazelnuts.

Oregon's Willamette Valley is the only place in the United States where the nuts are produced commercially, but that is expected to change, as Rutgers and Oregon State developed resistant plants by using sources of resistance in European species in their breeding programs. The teams are also creating hybrids between better adapted wild species that are disease resistant and very cold hardy, with improved nut quality and yield.

THE EQUINE SCIENCE CENTER:
EQUINE EXERCISE PHYSIOLOGY LAB

The Rutgers Equine Science Center is dedicated to better horse care through research and education to advance the well-being of horses and the equine industry. Since the lab opened its doors in 1995, research

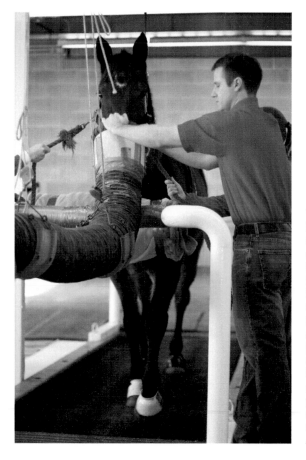

The Equine Exercise Physiology Laboratory at Rutgers University is a world-class facility that includes a high-speed equine treadmill. The Oxymax-XL is a system that measures the rate of oxygen inhaled (VO2) and the rate of carbon dioxide exhaled (VCO2) by a horse during exercise. A loose-fitting mask is placed over the horse's nose and held in a constant position to minimize experimental variability in measurements. *Courtesy of Rutgers Equine Science Center.*

partners have included organizations from pharmaceutical companies to the Department of Defense. The lab has conducted research looking into aging, the microbiome and general health in horses. In the case of the Department of Defense, the center conducted research using the horse as a model for research benefiting soldiers.

Located on the G.H. Cook Campus in New Brunswick, New Jersey, the Equine Science Center is recognized for its excellent physiology facilities and its efficient farm setup, which is capable of handling more than sixty horses at the same time. The Rutgers Equine Exercise Physiology Laboratory is one of only two such laboratories in the United States not associated with a veterinary college. The center has a twenty-one-foot-long treadmill to give the horses exercise. When one horse is on the treadmill, the others are eager to have a turn. Used for scientific research, the high-speed treadmill is popular with horses and humans alike.

The treadmill allows scientists and students to conduct a number of tests. The simulated race tests replicate the conditions that horses experience during a race. First, they warm up for two minutes at four meters per second. Then they run for two minutes at race speed, followed by a two-minute cool-down period.

Graded exercise tests challenge the horses' physiological systems and assess aerobic capacity. Horses walk on the treadmill at a 6 percent incline and then trot at four meters per second for one minute. Speed is then increased every sixty seconds until the point of fatigue.

A new complex called the Ryders Lane Facility is growing to become the national showcase for environmental best management practices for equine operations. The public can avail itself of these resources and learn more about ensuring the well-being, longevity, performance and advancement of horses through the website esc.rutgers.edu, which offers instant and ongoing access to the best thinking and best practices of the equine world.

And speaking of horses…

PERCHERON HORSES

Percheron Park, a new green space in Moorestown, New Jersey, commemorates the first Percheron horses shipped to the United States. Moorestown native and gentleman farmer Edward Harris II (1799–1863) brought the horses from France in 1839.

While traveling in France, Harris was amazed by the strength, stamina, speed, spirit and calm temperament of the horses that pulled the stagecoaches, called *diligences* in French. At that time, in the United States, English horse breeds were used in farming and road work. Harris began a breeding program with his stallion Diligence in order to improve the workhorses in America.

By 1930, there were almost three times as many Percherons in the United States than all the other draft breeds combined. Before the age of the automobile, Percherons made a huge impact on farming and hauling.

Edward Harris lived on his farm in a house now called the Smith-Cadbury Mansion, home of the Historical Society of Moorestown at 12 High Street. The new park to honor him is just steps away at 1 High Street.

BEYOND RUTGERS, THERE ARE OTHER FACTS AND INVENTIONS CONCERNING NEW JERSEY FARM PRODUCTS

New Jersey is a national top-ten producer of fruits and vegetables

FOOD AND AGRICULTURAL FACTS AND FIRSTS

2016 Statistics	Rank	Production	Production Value	Acres
Eggplant	2nd	14.8 million lbs	$ 5.2 million	800
Cranberries	3rd	56.9 million lbs.	$21.2 million	3,000
Spinach	3rd	30.7 million lbs.	$10.9 million	2,400
Asparagus	4th	5.6 million lbs.	$ 9.6 million	1,400
Bell peppers	5th	63.3 million lbs.	$20 million	2,300
Peaches	6th	42.2 million lbs.	$27.6 million	4,700
Cucumbers	6th	66.7 million lbs.	$16.8 million	3,100
Squash	6th	32.3 million lbs.	$13.7 million	3,400
Tomatoes	7th	79.1 million lbs.	$46.4 million	2,900
Apples	8th	36.0 million lbs.	$32.6 million	1,800
Blueberries	8th	48.6 million lbs.	$66.2 million	9,100

As of 2017, the state has nine thousand farms covering 720,000 acres. Sales generated in 2015 totaled $1.043 billion. Retaining productive, taxpaying farmland is critically important to all New Jersey residents, as agriculture is the largest single source of the scenic vistas we all enjoy throughout the year.

ASPARAGUS BUNCHER: ELIAS WATTS

The asparagus buncher, patented by Elias Watts of Keyport in 1887, was, as its name implies, used for gathering stalks of asparagus into bunches.

THE COONEY BLUEBIRD TRACTOR

In 1916, after five years of experimentation, Elizabeth C. White of the J.J. White Company in Whitesbog, New Jersey, and Frederick V. Coville of the U.S. Department of Agriculture, Washington, D.C., marketed the first domestic blueberry crop. This important event launched the modern blueberry industry. (See *A History of Inventing in New Jersey: From Thomas Edison to the Ice Cream Cone*, for more.)

To harvest this new crop, farmers used horses pulling plows or two-wheeled, walk-behind tractors. Some farmers, however, wanted a ride-on tractor that could navigate the narrow rows of plants. To meet this need, Cooney's Welding and Machine Shop in Mount Holly built the Cooney Bluebird, a compact, lightweight tractor manufactured from Ford Model A engines, with Model AA and Model TT truck components.

The first Bluebirds were probably built in the late 1930s, when older Ford parts were available. Cooney usually used the three-speed car transmission. The rear wheels were made from sixteen- to seventeen-inch car rims,

The Cooney Bluebird tractor. *Courtesy of Whitesbog Preservation Trust.*

mounted with tractor tires, while the front wheels were wide set with large tires, usually Model A wheels. The tractors were about four feet wide, seven feet long and four and a half to five feet high. Due to their construction, Bluebirds tended to skid, flip and get stuck.

The last Bluebirds were built in the late 1940s or early 1950s. They were replaced by the Farmall Cub and the Massey Harris Pony.

HUNTERDON COUNTY AGRICULTURAL INVENTIONS AND IMPROVEMENTS

Egg Washing Machine, Plastic Egg Trays

In 1909, Paul H. Kuhl founded the Kuhl Corporation, manufacturing equipment for poultry farmers. His sons, Paul R. and Henry, learned the trade and went on to run the business.

With this background, working with chickens and eggs came naturally to Henry. In the 1970s, he saw the need for plastic trays to hold the eggs during the cleaning process. Later, Henry invented a new egg-washing machine,

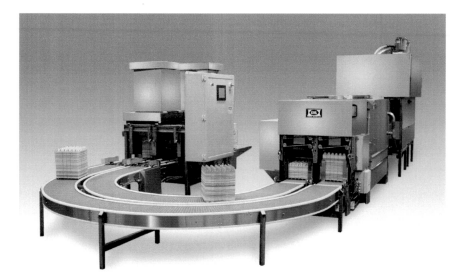

The Kuhl egg washing machine with dryer component. *Courtesy of the Kuhl Company.*

now the industry standard. His machines remove 99.98 percent of all shell-borne bacteria, including salmonella.

In addition to egg-washing equipment, Kuhl now manufactures customized machines to wash bakery and meatpacking trays, airline food-service carts, hospital equipment, animal cages, plastic delivery baskets and boxes, plastic totes used in fast food restaurants and almost anything that needs cleaning and sanitizing.

With a plastic egg tray washer setup for one-person operation, the operator loads stacks of plastic egg trays into the feed end of the washer, where they are automatically unstacked and placed individually onto the wash conveyor. After the wash cycle, the trays are automatically restacked and conveyed around a customized 180-degree turn into the centrifugal dryer unit. As the stacks leave the dryer, they are removed by the same operator who loaded the trays into the washer.

First Artificially Inseminated Birth

In February 1939, the nation's first artificially inseminated cow gave birth to a calf on the Stanton farm of Richard Schomp. His farm was just north of the Stanton Reformed Church in Hunterdon County, New Jersey. At the time, it was considered the most photographed and publicized bovine in history.

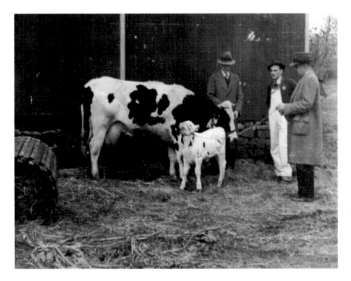

The first artificially inseminated cow gave birth to a calf on the Stanton farm of Richard Schomp. *Courtesy of the Hunterdon County Historical Society.*

Cooperative Egg Auction

In the 1930s, Flemington's Cooperative Egg Auction on Park Avenue was the first and largest in the world. Hunterdon County's poultry industry, once an enormous agricultural concern, was gone by the mid-1960s.

Chicken Tattoos

Dory Dilts was a Hunterdon chicken farmer who developed a system of tattoos for his chickens. Then if one was stolen, he could prove that it was his. It is uncertain where the tattoo was placed, but it may have been on the leg.

Deats Plow

In 1828, John Deats made a model of the celebrated Deats plow, which has become widely known. After obtaining a patent, he was unable to find a manufacturer. John headed west and never returned. His son Hiram later decided to try to have his father's plow manufactured for the use of his neighbors. This plow was an improvement, as it was multi-sectional and was stronger and easier to use.

At his farm near Quakertown, Deats made the castings for the manufacturing of the plow at a foundry he set up single-handedly. By 1836, he had added stove castings as well. His business prospered, and in 1852, Hiram bought an abandoned fulling mill complex to use as a foundry and machine shop in Pittstown. He then split his operation, making the stove castings at Stockton and manufacturing threshing machines, corn shellers and other agricultural implements in Pittstown. He then went into large-scale production of the plow, reapers and mowers. Deats formed a company with two partners, later changing its name to L.M. Deats & Company, which remained in business until 1904.

His son, Hiram E., became a noted historian of Hunterdon County. In 1929, Hiram E. presented one of his father's original plows to Rutgers University; it became the nucleus of the university's agricultural museum. A number of other farm implements from the company were given to the Hunterdon County Historical Society. Some are on display at the Red Mill Museum Village in Clinton and at the Holcombe-Jimison Farm Museum in Lambertville.

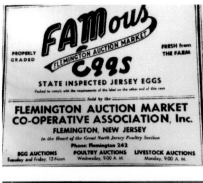

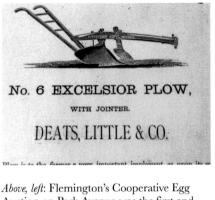

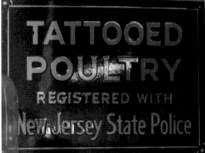

Above, left: Flemington's Cooperative Egg Auction on Park Avenue was the first and largest in the world. *Courtesy of the Holcombe-Jimison Farmstead Museum.*

Above, right: An advertisement for the Deats plow. *Courtesy of the Holcombe-Jimison Farmstead Museum.*

Left: Dory Dilts's idea for tattoos became official. *Courtesy of the Holcombe-Jimison Farmstead Museum.*

Hiram Deats is significant to New Jersey agricultural history for his production of the plow designed and patented by his father. Unchanged, it remained in use into the 1920s.

Cultivator

Oliver Kugler of Three Bridges received an 1831 patent for a cultivator (corn plow). He later had Deats manufacture it for him.

Shipment of Chicks by Rail

In 1892, Stockton-area poultryman Joseph Wilson became the first in the nation to ship newly hatched chicks by rail to his customers.

The Darlington Picker

In 1857 the Darlington family, cranberry growers, started cultivating cranberries, which were native to Burlington County's Whitesbog area (Pemberton Township). In the 1950s, Tom Darlington patented the Darlington Picker, which replaced the less efficient cranberry scoop for harvesting. The machine, which has teeth that allow vines—but not cranberries—to pass through, is still used today.

Floating Harvester

While the Darlington picker was a tremendous improvement over the scoop method, it was a tracked vehicle that moved back and forth in the flooded fields. Joe Darlington's wife, Brenda, was sure that 20 percent of the yield was being lost as the tracks rode over the stems at the bottom of the bog. She asked Joe to create a floating harvester so that no part of the vehicle would crush the stems.

Being an inventive guy, Joe designed a barge-like float that was controlled via strong, high-density, polypropylene ropes by workers standing on the sides of the bog. It worked! No part of the plant was crushed, and Brenda was very happy. A newer version is guided by GPS and uses stationary tractors with winches.

2

THE INCREDIBLE BELL LABORATORIES

I n 1881, Western Union was purchased by the American Bell Telephone Company, the forerunner of AT&T. It was renamed the Western Electric Company and became the manufacturing arm of Bell Telephone. The Western Electric Research Laboratories combined with part of AT&T's engineering department to form Bell Telephone Laboratories Inc. Bell Labs had a number of facilities in New Jersey, notably at Holmdel, Whippany and Murray Hill.

My previous work, *A History of Inventing in New Jersey*, included many inventions from Bell Laboratories. Among these were the first synchronized moving picture and audio, the first artificial larynx, the transistor, solar panels, the maser, the laser, the UNIX operating system and the charge-coupled device.

Here are a few more creations from this exceptional company.

THEODORE "TOD" SIZER, BELL LABS: LIGHTRADIO CUBE

Tired of those cell towers that pretend to be trees or flagpoles? Or those tall, unsightly structures that dot the landscape?

Led by researcher Tod Sizer, scientists at Bell Labs in Murray Hill, New Jersey, have created the lightRadio cube, a device that could transform wireless networks and the way the wireless industry operates.

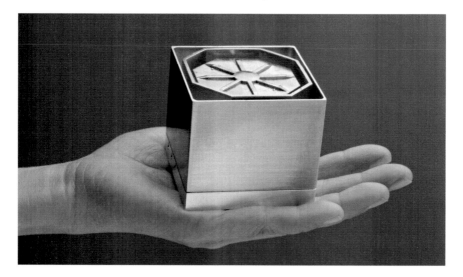

Bell Labs lightRadio. *Reused with permission of Nokia Corporation.*

While current cell phone antennas must be large and high in order to send signals down and outward, the lightRadio focuses phone signals more directly, using far less power and handling up to 30 percent more capacity than current towers.

The new cubes are tiny, about two or three inches in width and height. They do not have to be hundreds of feet in the air because they send the signal directly to where it is needed. The cubes can handle about 30 percent more traffic than standard cell phone towers. In addition, multiple cubes can be grouped together for more power. No towers would mean no more dead zones.

At first, Sizer's global team members told him that the task was impossible. But two months later, an inventor in Stuttgart, Germany, showed Sizer his creation: three two-inch, stacked circuit boards for the antenna, radio and network connection, replacing the conventional antenna system that connects every cell phone call. It has been tested and proved to be workable.

The scientists at Bell Laboratories, now part of Nokia, have been awarded many prizes for their work. On April 8, 2015, Bell Labs dedicated its new Nobel Laureate Garden, commemorating the achievements of the fourteen Bell Labs Nobel laureates, who have shared eight Nobel prizes in physics and chemistry.

THE NOBEL PRIZE

Fourteen scientists from Bell Labs have been awarded the Nobel Prize.

ERIC BETZIG was awarded the Nobel in Chemistry in 2014 "For the Development of Super-Resolved Fluorescence Microscopy."

WILLARD BOYLE and GEORGE SMITH were awarded the Nobel Prize in Physics in 2009 for the invention of the charge-coupled device (CCD), which made the CCD image sensor possible.

HORST STORMER, DANIEL TSUI and ROBERT LAUGHLIN were awarded the Nobel Prize in Physics in 1998 for the discovery and explanation of a new form of quantum fluid with fractionally charged excitations (the Fractional Quantum Hall Effect).

STEVEN CHU was awarded the Nobel Prize in Physics in 1997 for the development of methods to cool and trap atoms with laser light (prize shared with Claude Cohen-Tannoudji and William D. Phillips).

ARNO PENZIAS and ROBERT WILSON were awarded the Nobel Prize in Physics in 1978 for the discovery of cosmic microwave background radiation that in turn provided clear substantiation of the big bang theory of how the universe began.

PHILIP ANDERSON was awarded the Nobel Prize in Physics in 1977 for fundamental theoretical insights into the electronic structure of magnetic and disordered systems (prize shared with Sir Nevill Francis Mott and John Hasbrouck van Vleck).

JOHN BARDEEN, WALTER BRATTAIN and WILLIAM SHOCKLEY were awarded the Nobel Prize in Physics in 1956 for research on semiconductors that led to the invention of the transistor in 1947.

CLINTON DAVISSON was awarded the Nobel Prize in Physics in 1937 for the discovery of the diffraction of electrons by crystals and demonstrated the wave nature of matter. (The prize was shared with George Paget Thomson.)

THE U.S. NATIONAL MEDAL OF SCIENCE

The National Medal of Science is an honor bestowed by the president of the United States to individuals in science and engineering who have made important contributions to the advancement of knowledge in the fields of behavioral and social sciences, biology, chemistry, engineering, mathematics and physics. Twelve Bell Labs scientists have been awarded this medal.

C. KUMAR PATEL was awarded the National Medal of Science in 1996 for the invention of the carbon dioxide laser, which led to numerous scientific, industrial and medical applications.

JAMES FLANAGAN was awarded the National Medal of Science in 1996 for applying engineering techniques and speech science to solve underlying problems in speech communication.

AL CHO was awarded the National Medal of Science in 1993 for pioneering research leading to the development of molecular beam epitaxy, a technique that revolutionized thin film growth, making possible atomically accurate structures for electronic optoelectronic devices and for the study of new quantum phenomena.

WILLIAM O. BAKER was awarded the National Medal of Science in 1988 for pioneering studies of the complex relationships between the molecular structures and physical properties of polymers, a distinguished record of leadership in the combined disciplines of science and engineering and distinguished service to government and education.

SOLOMON BUCHSBAUM was awarded the National Medal of Science in 1986 for contributions to science and technology policy in the United States.

PHILIP ANDERSON was awarded the National Medal of Science in 1982 for fundamental contributions to the theoretical understanding of condensed matter.

RUDOLF KOMPFNER was awarded the National Medal of Science in 1974 for the invention of the traveling-wave tube as well as highly significant scientific insights underlying communication satellites and optical communications.

JOHN TUKEY was awarded the National Medal of Science in 1973 for mathematical and theoretical statistical contributions, including the analytical tool known as fast Fourier transform for understanding wave forms in fields from astrophysics to electrical engineering.

JOHN PIERCE was awarded the National Medal of Science in 1963 for contributions to communications theory, electron optics and traveling wave tubes and for the analysis leading to worldwide radio communications using artificial earth satellites.

ARTHUR SCHAWLOW was awarded the National Medal of Science in 1991 for the conception of the laser and in advancing its applications, especially in laser spectroscopy.

CHARLES TOWNES was awarded the National Medal of Science in 1982 for contributions to the understanding of matter through its interaction with electromagnetic radiations and the application of this knowledge toward the invention of the maser and laser.

CLAUDE SHANNON was awarded the National Medal of Science in 1966 for brilliant contributions to the mathematical theories of communications and information processing.

In addition, many Bell Labs scientists have been inducted into the National Inventors Hall of Fame and the New Jersey Inventors Hall of Fame. Other prizes awarded to Bell Labs scientists include the Oscar, Emmy, Grammy, Brain Prize, Dahl-Nygaard, Marconi, Queen Elizabeth, Edison and many others. To learn more, please visit https://www.bell-labs. com/our-people/recognition.

3

EDISON'S AMAZING INVENTIONS

I n volume one, *A History of Inventing in New Jersey*, a number of Edison's more famous inventions were included. But he and his "muckers," as he called his team, created many other practical inventions.

His first research and development laboratory opened in 1876 in Menlo Park, New Jersey. There, his team created the telephone transmitter, the phonograph and the first system of incandescent electric light and power. In 1887, he opened a new and larger laboratory in West Orange, New Jersey. During the thirty-five years he worked at this laboratory, Edison invented the first successful motion picture camera, developed better phonograph and record technology, created a system for refining low-grade iron ore, invented an alkaline storage battery and improved cement manufacturing technology.

FIRST CARBON TELEPHONE TRANSMITTER

Edison did not dispute the fact that Alexander Graham Bell invented the telephone. But from the beginning, Bell's transmitter was not very good. It was too faint to hear over any great distance. Edison was asked by Bell's competitor, the Western Union telegraph company, to invent a better one.

For several years, he experimented with many different methods to improve the transmitter. He used carbon in soft powder form, porous paper kept dangling in a pot of water, loose wire and soft carbon powder. All of these methods had some drawbacks. Finally, he used a soft powder made

from burning hydrocarbons at the lowest temperature. This generated soot, which could be compressed into cakes, ground again and pressed into carbon buttons.

These carbon buttons were the answer, as they provided contact points that the sensitive transmitter needed. If the transmitter was designed so the button stayed in contact with the diaphragm, the carbon button would work and not be damaged.

In May 1877, Edison assigned all of his telephone patents, including the carbon button transmitter, to Western Union for an annual payment of $6,000 per year for seventeen years. Western Union then agreed with the Harmonic Telegraph Company, which controlled Elisha Gray's telephone patents, to form the American Speaking Telephone Company in November 1877.

ELECTRIC PEN

We know many of Edison's more famous creations: phonograph, power system, improved light bulb and motion pictures. But did you know that he invented the electric pen, which later morphed into the mimeograph? While there was carbon paper to make a few copies, and costlier print shops to make many more, the electric pen could make thirty copies of a test for a class or hundreds for bulletins or posters.

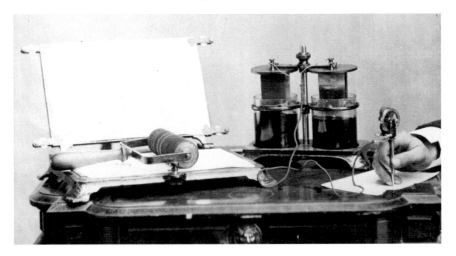

The electric pen could make thirty copies of a test for a class or hundreds for bulletins or posters. *Courtesy of the Thomas Edison National Historical Park.*

The patent Edison received on August 8, 1876, covered the flatbed duplicator and an electric pen for cutting the stencils. Later, Albert Blake Dick improved the stencils and merged his efforts with Edison.

In later years, the flatbed machine was replaced with a cylindrical version, and the electric pen was replaced by the typewriter. The process was known as "running things off," as in, "I'll run off thirty copies of this math test." To do this, one had to cut a stencil by typing or writing on it and then attach the stencil to the machine. Turning the handle turned the cylinder, pushing ink through the holes on the stencil and onto the blank pieces of paper.

A SYSTEM FOR REFINING LOW-GRADE IRON ORE

In 1880, Edison developed an electromagnetic device to separate iron ore from the materials around it. The sand, or tailings, dug up were poured through a hopper into the separator. It then passed in a stream in front of the electromagnet, which attracted any magnetic particles, such as iron. The magnetic material went into one bin and the non-magnetic into another.

For his later venture into iron ore, between 1887 and 1898, he built a complex in Ogdensburg, New Jersey, to crush, separate and concentrate the ore in briquettes, similar to hockey pucks. The Mesabi Iron Range was discovered in Minnesota in 1866, and the first mine opened in 1892. From that time, well into the twentieth century, it produced one-fourth of all the ore in the United States. Edison's low-grade ore became too expensive for steel mills, and he abandoned his Ogdensburg operation.

Always the innovator, Edison recouped part of his investment by transferring his rock-crushing technology to the production of Portland cement.

IMPROVED CEMENT MANUFACTURING TECHNOLOGY AND CONCRETE HOMES

During the iron ore project, Edison discovered that he could sell the leftover sand to cement manufacturers. When his iron ore operation closed, Edison made other improvements in cement manufacturing. Most importantly, he created a long rotary kiln and used it at his automated plant in Stewartsville, New Jersey. In addition, he licensed the kiln to other companies.

Thomas Edison relaxes at his Ogdensburg mine site. *Author's collection.*

Edison's Portland cement was used to build dams and other structures, including the original 1923 Yankee Stadium. His first concrete road, marked by historical plaques, is part of Route 57 in New Village, Warren County. Edison laid this stretch of highway in 1912 to test the effectiveness of concrete as a paving material.

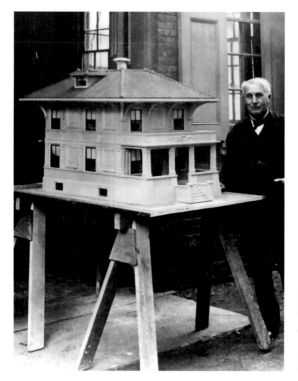

Left: Model of a concrete house that Edison perfected using cast-iron molds. *Author's collection.*

Below: Concrete house under construction. *Author's collection.*

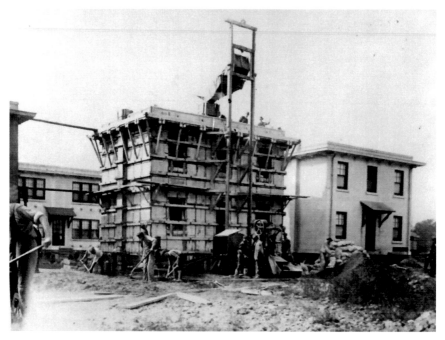

One of the great inventor's lesser-known creations is the concrete house, a building made using cast-iron molds. He created a series of molds held in place by trusses and dowels. The concrete was pumped in by compressed air in one continuous flow. Spaces for pipes and other conduits were set into the molds before the concrete was introduced. The only wooden items were the doors, window sashes and a few strips to which carpet could be attached. The three-story homes had nine rooms, plus a cellar.

It took six hours to pour the concrete and six days for it to set. Several of these homes, dating from the 1930s, dot the Valley View neighborhood of Phillipsburg. Others can be found in Union and Montclair.

An article in the June 1965 issue of *Concrete Construction* magazine described the Edison method of building a concrete home:

> *Basic to the plans were Edison's ingeniously conceived cast-iron molds, which when assembled would produce, in a single operation, walls, floors, stairways, roof, bath and laundry tubs, and conduits for electric and water service. As many as 500 different sectional molds were required for a single unit. Moreover, because of the intricate tracery being attempted, each mold had to be faced with nickel or brass. The cost per set of molds soared to $25,000. Nevertheless, since each set of molds could be re-used indefinitely, Edison estimated the cost per house unit at $1,200, including plumbing, heating, and lighting fixtures.*

The molds could be used in different combinations so that all of the homes would not look the same. A distinct advantage is that these homes are warmer in the winter and cooler in the summer, due in part to the six-inch-thick walls.

While Edison was not in the business of building concrete houses, developers could buy his molds. But as Leonard DeGraaf, archivist at the Thomas Edison National Historical Park in West Orange, pointed out, "Edison told the *New York Times* that the cost for getting the molds and the equipment a builder needed was approximately $30,000 which, in 1907, is a lot of money. So the system wouldn't be cost-effective unless a developer was building a lot of houses."

ALKALINE STORAGE BATTERY

What was Edison's most profitable product? Not the light bulb or phonograph—it was the alkaline storage battery.

In the 1910s, Edison spent a lot of time working on a storage battery that could be used in electric automobiles. He had experimented with batteries earlier but could not solve the problems presented by the need to replenish chemicals and electrodes in wet cells. Since lead-acid batteries were very heavy, Edison experimented with alkaline electrolytes to develop a lightweight and long-lasting battery. It took him a decade to develop a commercially viable iron-nickel battery, but by that time, most cars were powered by internal combustion engines. Ever the businessman, however, Edison did find a large market for his battery in a variety of industrial uses, and it was the most successful product of his later life.

EDIBLE INVENTIONS

AN UPDATE ON M&M'S

M&M/Mars is the largest employer in Hackettstown, New Jersey. *Courtesy of Robert H. Barth.*

In volume one, *A History of Inventing in New Jersey*, I told the story of the beginning of the M&M/Mars Company. Since then, I have found a few more interesting tidbits about this delectable treat.

The iconic candy-coated chocolate celebrated its seventy-fifth birthday in 2016. In previous years, almost no one was allowed to tour the plant. Recently, though, reporters from several newspapers have been privy to the inner workings. They have written about the conching machines, in which chocolate is mixed with cocoa butter and smoothed. These are the same machines used in the Newark plant when the product was first made in 1941.

One thing that hasn't changed: no visitor, and not even all employees, may see the room in which the familiar M is printed on each tiny candy. And no, there are no Oompa Loompas working in there.

Did you know that the astronauts on the space shuttle *Columbia* asked for M&M's, making them the first candy to go into space? That was April 12, 1981, and M&M's were on board for the next 134 shuttle missions.

Another new idea is the company's Dove Chocolate Discoveries program. Women are invited to "be a chocolatier, no experience needed" and host a home chocolate party. (Like Tupperware®, only tastier.) The author is planning a date in the near future.

In addition to the milk chocolate and peanut flavors, the company has added peanut butter, crispy, pretzel, dark chocolate, almond, dark mint, dark chocolate peanut, the mega size and even an M&M's chocolate bar.

FIRST BEER CAN: AMERICAN CAN COMPANY AND KRUEGER BREWING COMPANY

Late in 1933, just before the repeal of Prohibition (December 5, 1933), the American Can Company created a workable beer can. All that the company needed was a brewer willing to volunteer to try it. The Gottfried Krueger Brewing Company of Newark, New Jersey, stepped up to pioneer this new container, signing the contract in November 1933.

By the end of that month, American had installed a temporary canning line and delivered two thousand Krueger's Special Beer cans, which were promptly filled with 3.2 percent Krueger beer—the highest alcohol content allowed at the time. Krueger's Special Beer thus became the world's first canned beer.

The two thousand cans of beer were given to faithful Krueger drinkers; 91 percent gave it thumbs up, and 85 percent said it tasted more like draft than bottled beer. Reassured by this successful test, Krueger gave canning the green light, and history was made.

DRAFT TOP: ARMAND FERRANTI

Armand Ferranti of Long Branch has created a bar tool that removes the top of a can and makes it into a safe drinking glass. The Draft Top is a patent-pending mechanical tool designed to remove the top of a can without any sharp edges while maintaining the structural integrity of the can.

The design uses four rotational splitter blades. The blades sit inside the rim of a can and use pressure to split and fold the lid as it turns. It takes approximately one-quarter turn to complete the separation.

According to Armand, "The Draft Top is a bar tool that was designed to better the experience of drinking from cans by safely removing the top

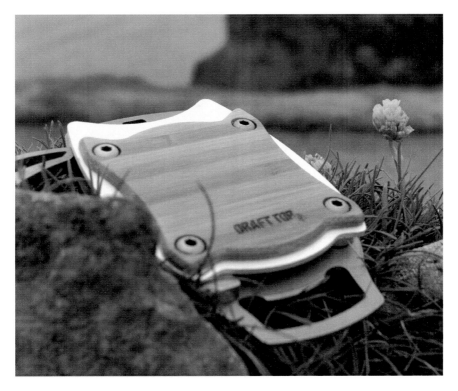

The Draft Top is a mechanical tool designed to remove the top of a can without any sharp edges while keeping the integrity of the can. *Courtesy of Sean Kelly.*

of the can but still leaving the smooth, pressed-on rim in place, effectively turning the beer can into a pint glass. (Yes, it opens sixteen-ounce cans, too).

> *The original idea came from being shown how to use my tooth to open a can back in 2000. Separate from the barbaric act, I noticed that canned beer was much more enjoyable when it didn't have the top on it. Fast forward twelve years....I was asked to open a bottle of wine at dinner while drinking a can of beer, and when I grabbed the foil cutter, the light bulb went off. What if you could use a device like this to open beer cans? Now three years and several iterations later, Draft Top is ready for the world to use.*

Among the benefits, Draft Top gives the fuller flavor of the beverage and is eco-friendly in that it reduces the carbon footprint by using fewer plastic cups. In addition, you can wash and reuse the cans. The Draft Top was specifically designed for eight- to sixteen-ounce beverage cans

with standard tops. It does not work on CROWLERS®, certain tallboys or soup cans.

(Note: A CROWLER® is a thirty-two-ounce can filled with fresh craft beer from the source. Yes, draft beer in a portable growler-sized can.)

THE GREEN BEAN CASSEROLE: DORCAS REILLY

Often a traditional dish at Thanksgiving in the Midwest, green bean casserole has a strong New Jersey connection.

It was concocted in the kitchens of Campbell's Soup in Camden, New Jersey, by Dorcas Reilly. After graduating from the home economics program at Drexel University in Philadelphia in 1947, Dorcas worked for Philadelphia Electric, teaching homemakers how to cook on the newfangled electric ranges.

Next, she moved across the Delaware River to Camden for a job in the Campbell's Soup test kitchens. Part of her job involved traveling to the NBC studios in New York City each week to prepare food for live commercials on television.

In a small room off the set of the *Henry Aldrich Show*, she prepared food on two heating elements. Then, during commercial breaks, she brought the hot dish to the set so that the Campbell's executives could describe it to the viewing audience. "They would tell me what I was to prepare for the live commercial breaks during the show in Studio 3B. I did everything from shopping for what I needed to preparing the food on the set. Campbell's sponsored the show from 1951 until it ended in May 1953," recalled Reilly.

She added, "Most times there wasn't time for me to get out of the camera shot so I would hide under the table until the commercial was over."

Two years later, still working for Campbell's, Dorcas and her team created the classic green bean casserole. They were looking to combine different textures and flavors using Campbell's cream of mushroom soup as the base. She threw in a crunchy onion topping and—voilà—the famous dish was born.

PINK LEMONADE: WILLIAM GRIFFITH

According to "Hunterdon County, 1714–2014, 300 Years of History," William Griffith of Three Bridges was featured on ABC Radio in 1937 as

the inventor of pink lemonade. When the circus was in town, so the story goes, the wind had blown the fat lady's pink tights into Griffith's vat of lemonade. He sold it anyway, and a new craze was born. True or not, it's a great story.

PORK ROLL, ALSO KNOWN AS TAYLOR HAM: JOHN TAYLOR

John Taylor began producing pork roll in Trenton in 1856, and it's still made there today by Taylor Provisions on Perrine Avenue.

Officially called "Original Taylor Pork Roll," it is also known as Taylor ham. When John Taylor first created the product, he called it "Taylor's Prepared Ham," but since it did not meet the Pure Food and Drug Act's definition of ham, he was forced to change the name in 1906.

Taylor sued others who manufactured pork roll with names similar to his product. But in 1910 the court ruled that the name "pork roll" could not be trademarked. It was described as "a food article made of pork, packed in a cylindrical cotton sack or bag in such form that it could be quickly prepared for cooking by slicing without removal from the bag."

John Taylor wanted to keep the recipe a secret, and so it is to this day. Pork roll is generally sold in one-, three- or six-pound unsliced rolls packed in a cotton bag. Customers can also buy it pre-sliced. Pork roll can be found at delicatessens, diners, lunch stands and food trucks in the region.

It is usually sliced and grilled and often eaten on a roll with egg and cheese. Devotees and those who are just curious can attend the annual New Jersey Pork Roll Festival in Trenton in May.

Vincenza Pork Roll, from Whole Foods, has varied the flavor by grinding the fatty backing along with the pork loin and seasoning it with salt, white pepper and coriander. Charles Ventre, hired by Whole Foods to update this New Jersey classic, said, "A key ingredient is a little port wine." He ferments his mixture for twenty-four hours before steaming it in specially made linen bags. His product is pricy, due to his use of pork raised without antibiotics or hormones. He hopes to manufacture his pork roll in the Garden State, pending approval from Whole Foods.

SMARTIES® CANDY

Now manufactured in Union, New Jersey, Smarties® candy is said to be America's favorite candy wafer roll.

When Edward Dee came to America in 1949, he set up his factory in a rented building in Bloomfield. Using only two machines, he founded Ce De Candy, which has now been in business for almost ninety years. After ten years in Bloomfield, Eddie Dee moved his company to Elizabeth and to Union in 1967. Now called Smarties Candy Company after a name change in 2011, the company has two facilities in Union.

Dee opened a Canadian manufacturing operation in Toronto in 1963, moving it to Newmarket, Ontario, in 1988. In Canada, the candy is marketed as Rockets®.

In both the U.S. and Canadian facilities, candies are made twenty-four hours a day, producing billions of rolls each year. They are gluten-free, peanut-free, dairy-free, worry-free and only twenty-five calories in a roll.

Products include Lollies, Mega-Lollies, Tropical Lollies, Smarties in a pouch, X-treme Sour Smarties, Love Hearts, Candy Money and more.

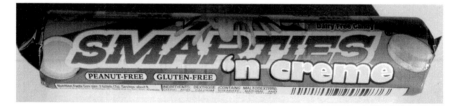

A roll of Smarties candies. *Courtesy of the Union Township Historical Society.*

FORT MONMOUTH, CAMP EVANS AND THE U.S. ARMY SIGNAL CORPS INVENTIONS

SECRET THEN, FASCINATING NOW

R ecognizing the need to improve communications for the large armed force that was about to head for Europe to take part in World War I, the U.S. Army established Fort Monmouth as the expanded home for the Signal Corps in the spring of 1917. Originally called Camp Little Silver, its name was changed in September 1917 to Camp Alfred Vail to honor the co-inventor of the telegraph. In 1925, the name was officially changed to Fort Monmouth to memorialize the soldiers who died in the 1778 Battle of Monmouth during the Revolutionary War.

In 1914, Camp Evans was the Marconi Belmar Trans-Atlantic Wireless station, which opened worldwide wireless communications and played an important role in World War I transatlantic communications. Camp Evans was also the first campus of the King's College. The camp played a key role in the development of radar as an effective World War II secret weapon, opened space communications in 1946 and was a Cold War technology site and a nuclear weapons research site. The camp was visited by Senator Joseph McCarthy, as he suspected a communist spy ring was operating there. It was the birthplace of satellite-based hurricane tracking, was a pre-NASA space research site and is now a black history site.

Together, Fort Monmouth, Camp Evans and eight to ten other nearby sites created the innovations that led to victory in World War II and advanced the United States to preeminence in the space age.

Between World War I and World War II, scientists with the Signal Corps Laboratories developed aircraft-detection radar and participated in creating

the first weather radar, the first weather satellite, the first televised weather satellite, the first communications satellite and the first high-capacity communications satellite. The soldiers here also conducted research on air-to-ground radios and direction finding by radio. In 1918, Signal Corps pilots flew over ninety flights per week as part of the research to develop these ground-to-air radios—so many planes, in fact, that local folks thought the camp was an airfield.

The first radio-equipped weather balloon was launched at Fort Monmouth in 1928. This marked the first major innovation in the field of applying electronics to the study of weather and upper atmospheric conditions. Among its related achievements was the first portable weather station. The Signal Corps was actually able to *do* something about the weather when it created the seeding of clouds with silver iodide and dry ice. It is thought that this technology was successfully used in Vietnam to clear cloud cover.

During the 1930s, Fort Monmouth produced much of the communications equipment that the U.S. Army used during World War II. The walkie-talkie

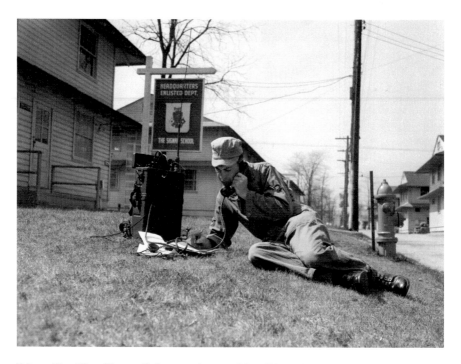

Private First Class Clayton Coleman using a walkie-talkie, which came equipped with a radio receiver-transmitter, a case, carrying harness, antenna, handset, belt suspenders and combat belt. *Courtesy of the U.S. Army Communications–Electronics Command History Office.*

was probably the best known, but the laboratories also built six field radio sets, switchboards, radio receivers and an Air Corps mobile transmitter. The same decade also saw the development of a radio that could be used in a vehicle; it had a range of five miles.

In 1951, a more advanced walkie-talkie, the AN/PRC-10, included the transmitter, case, carrying harness, belt suspenders and combat belt.

RADAR: COLONEL WILLIAM R. BLAIR, 1941–45

One of the most important developments at Fort Monmouth was RADAR (Radio Detection and Ranging). The term was first coined by the navy in 1941, and it was accepted by the army in 1942.

Colonel William R. Blair, known as the father of radar, proved that radar could detect and measure the speed of aircraft using a system of heat and radio pulse-echo detection. The patent for the first American radar was awarded to Colonel Blair; the system was developed and tested at Fort Monmouth.

Colonel Blair held eleven patents, including one for the radiosonde, a small device that, as it rises on a balloon, transmits temperature, pressure, direction, speed of wind and humidity. On the ground, the Rawin Display can track the radiosonde up to 100,000 feet in altitude and 125 miles away.

This unidentified soldier holds Colonel Blair's radiosonde, a small radio transmitter sending back information on temperature, pressure, wind speed and humidity as it rises. *Courtesy of the U.S. Army Communications–Electronics Command History Office.*

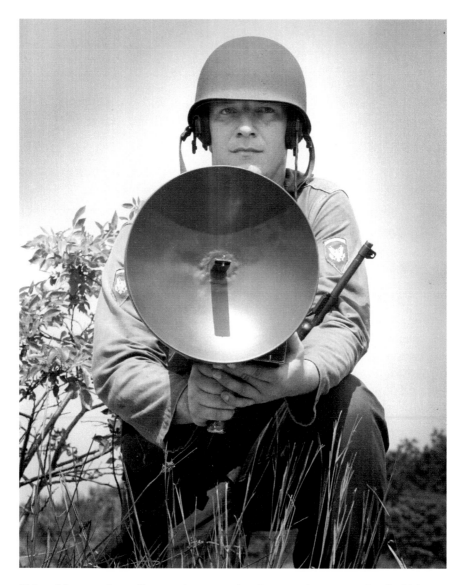

Lightweight ground surveillance radar was used to detect moving personnel and vehicles day or night in all weather conditions. *Courtesy of the U.S. Army Communications–Electronics Command History Office.*

During World War I, Blair worked with the U.S. Army's Signal Corps and developed his radar theory. His theory became reality during World War II, when he invented radar. During wartime, however, the invention had to be kept secret, and Blair was not allowed to apply for a patent.

When the war ended in 1945, Blair applied for a patent, but it was challenged by others who claimed to have been the inventors. Finally, after a special act of Congress and extensive research, he was awarded the patent in 1957. The U.S. Army has said that the invention of radar was "as important and far-reaching in its military application as the first U.S. patent issued on the telephone was to commercial communications."

Radar was developed due to the need to detect the possibility of massive aerial bombardment. In 1938, the first U.S. aircraft-detection radar was developed at Fort Monmouth. One of the first uses of radar was at the naval base at Pearl Harbor.

Privates George Elliott and Joe Lockard were the radar operators on the morning of December 7, 1941. At 7:02 a.m., they detected a large echo on the SCR 270 radar. According to protocol, the two soldiers reported the anomaly to the Aircraft Warning Information Center. The only officer on duty had no training in radar, but he was aware that a flight of B-17 Flying Fortresses was due in that day. Believing that the B-17s were the objects detected on the radar, he told the operators not to worry about it. Since their shift was up, they returned to base.

Shortly after 8:00 a.m., Lockard and Elliott learned that Japanese aircraft were attacking the base at Pearl Harbor and realized that what had appeared on the radar was the Japanese attack force.

THE REGENERATIVE CIRCUIT

In January 1914, Edwin Armstrong developed the regenerative circuit, a key to radio development. Armstrong demonstrated the circuit to David Sarnoff at the Marconi Belmar Station.

STATIC ELIMINATION

During World War I, Roy Weagant solved a perplexing problem. Static in the form of bangs, hisses and crashes disrupted transoceanic communication on a regular basis. Working in New Jersey and Florida, Roy created a system that removed the static so that the wireless transmission of human voices was clear and understandable. This innovation was kept secret to allow the Allies an important communications advantage over the Germans. Mobile wireless sets made at the base in Aldene, New Jersey, were shipped overseas to pick up German communications.

HOMING PIGEONS

Due to the successful use of homing pigeons during World War I, the army continued the service after the war. The Signal Corps Pigeon Breeding and Training Section was established at Camp Alfred Vail. The British supplied 150 pairs of breeding birds, which arrived at Camp Vail in October 1919. They lived with some of the birds that had performed heroically during the war.

Right: Homing pigeon, a veteran of World War I. *Courtesy of the U.S. Army Communications–Electronics Command History Office.*

Below: In this 1930s pigeon loft, trainers separated breeding birds from racers. It took several days to "home" a pigeon so it would know where to return. *Courtesy of the U.S. Army Communications–Electronics Command History Office.*

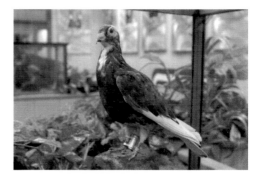

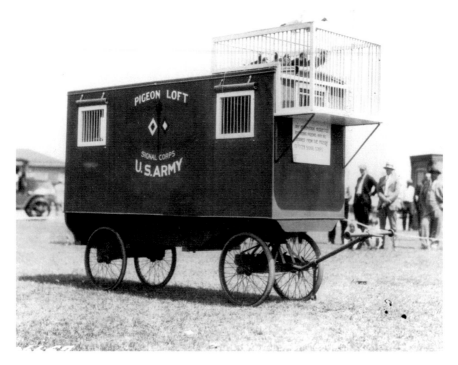

In the 1920s, the Signal Corps officers trained pigeons to fly under cover of darkness. As World War II began, they had trained two-way pigeons, with the first test flight in 1941. Twenty birds completed the twenty-eight-mile round trip from Fort Monmouth to Freehold, New Jersey.

By 1957, with great advancements in communication, the pigeon service was discontinued. Fort Monmouth sold many pigeons at auction; the "hero" pigeons from the war retired to zoos.

FOREIGN LANGUAGES

During World War I, Camp Alfred Vail offered an intensive, six-week course learning foreign codes and languages. This was necessary, as there was an urgent need for radio operators and telegraphers in France.

CAMERAS

In 1954, Fort Monmouth produced the AN/PFH-2, a one-hundred-inch, long-range camera that could photograph battlefront activity up to thirty miles away. In 1956, the Signal Corps Laboratories developed an eight-pound tactical television camera that had built-in batteries instead of the cable connections of the earlier models.

MOBILE COMPUTER

The world's first mobile, van-mounted computer, the MOBIDIC, was created at Fort Monmouth in 1960. It automated combat support functions and was used on the battlefield.

RADIO AND FIELD WIRE

The Signal Corps Radio Laboratories focused on designing and testing radio sets and field wire equipment. One version, used in Korea, could be laid down by planes at 120 miles per hour, and they had a range of 12.5 miles.

Helicopters and planes could lay field wire at speeds of up to 120 miles per hour, providing a talk range of about 12.5 miles. *Courtesy U.S. Army Communications–Electronics Command History Office.*

TIROS WEATHER SATELLITE

Not counting the developments that led to the Allied victory in World War II, the TIROS weather satellite is the invention that probably saved the most lives, allowing huge populations to receive warnings of impending hurricanes and other weather phenomena.

In 1928, the first radio-equipped meteorological balloon soared into the upper reaches of the atmosphere, a forerunner of a weather-sounding technique universally used today.

The many scientists who worked at the U.S. Army Signal Research and Development Laboratory in Wall Township, New Jersey, pooled their talents to create TIROS, the Television Infra-Red Observation Satellite.

Although it worked for only seventy-eight days, TIROS proved that America could put a satellite into orbit and take pictures when it got there, surpassing the ability of the Soviets' Sputnik. Launched on April 1, 1960, the satellite

took almost twenty-three thousand photos sent back to earth via a sixty-foot dish-shaped antenna that still exists at Camp Evans in Wall Township.

The first picture was hand-delivered to President Eisenhower, who sent copies to the Russians and the Chinese as a "gesture of good will." He noted that TIROS was taking photos of both countries. When TIROS sent back a photo of a cloud formation with a hole in the middle, hurricane tracking was born. Who can predict how long it would have orbited if a power failure had not ended its mission? But it led the way to the weather technology used today.

TIROS was built by the RCA Astro Division in Princeton, tested at Camp Evans and launched by NASA. Three satellites were built. The third is on display at the Smithsonian.

Additional weather-related items were developed, including the "Breeze Buster," a weather gun that could aim and hit itself with a round-trip bullet, allowing personnel to measure low-altitude wind velocity.

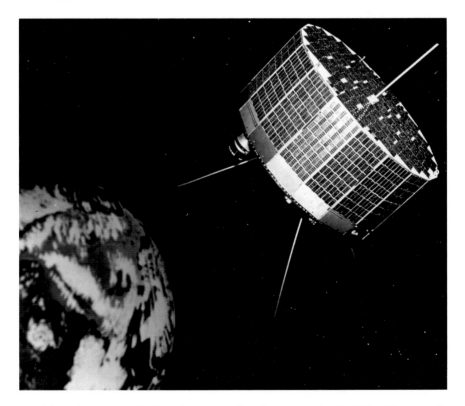

TIROS (the Television Infra-Red Observation Satellite) proved that the United States could put a satellite into orbit and take pictures when it got there, surpassing the ability of the Soviets' Sputnik. *Courtesy of the U.S. Army Communications–Electronics Command History Office.*

THE ELECTRONIC COMMAND'S NIGHT VISION LABORATORY

The Night Vision Laboratory produced the Night Observation Device, which had the greatest range of any of the night sights. Mounted on the ground or on a tripod, this device could detect enemy activity in moonlight or starlight at distances of up to 1,200 meters.

Another device could be used with machine guns and rifles, allowing soldiers to see in starlight or moonlight nearly as well as they could in daylight.

NIGHT VISION GOGGLES: RUDOLF BUSER

The U.S. Army CECOM dedicated building 6006 in memory of Dr. Rudolf Buser, a night vision pioneer. A veteran of thirty-eight years in the civil service, Dr. Buser joined the staff at Fort Monmouth in 1958 as the team leader and technical area chief at Fort Monmouth's Institute for Exploratory Research. He became the laser division director at the Night Vision and Electronic Sensors Directorate (NVESD). Under his leadership, the team

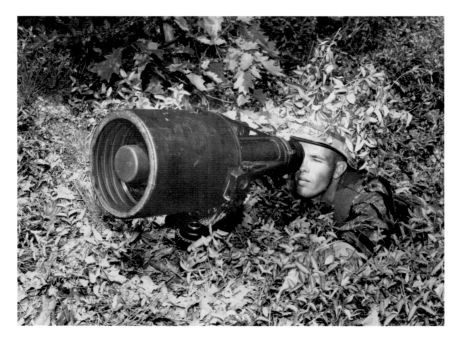

This was the largest night vision observation device developed by the Night Vision Laboratory. *Courtesy of the U.S. Army Communications–Electronics Command History Office.*

developed the laser rangefinder/designator/trackers, laser radars, laser identification friend or foe (IFF), laser countermeasures and laser-aided surveillance and target acquisition systems. In 1983, Dr. Buser received the Meritorious Civilian Service Award for his contributions to the Intelligence and Security Command in the field of electro-optics.

Dr. Buser retired in 1996 but remained an active supporter of the Research, Development and Engineering Command. He died on February 15, 2007.

DIAMOND-MAKING MACHINE

In 1960, the Signal Corps produced a hydraulic press that used graphite to make diamonds. In this operation, a graphite and metal charge was put under 1.25 million pounds of pressure per square inch in a two-stage pressure chamber.

JUNGLE RADIO

Research was done in Thailand on a pachyderm radio, carried on an elephant when military vehicles could not get through the wet terrain. The antenna was stretched between the animals.

BACKPACK RADIO

The SCR-510, an early backpack radio, gave the troops on the front line reliable, static-free communications. This invention was in use in the European theater of operation as early as 1943.

DIANA TOWER:
LIEUTENANT COLONEL JOHN J. DEWITT

Designed in 1946, the Diana Tower was a specially designed radar antenna that reflected electronic signals off the moon. (It was named for Diana, Roman goddess of the moon.) The Diana antenna focused a beam of high-frequency energy at the moon, traveling at the speed of light (186,000 miles

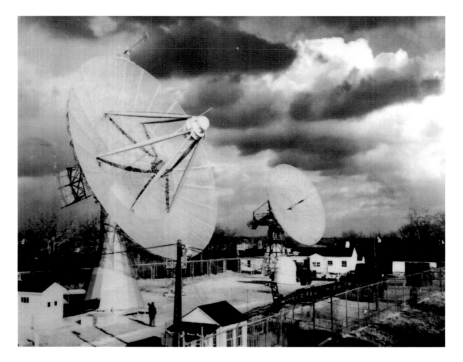

Project Diana played a key role in the Space Race. It was a satellite tracking and meteorology development site. *Courtesy of InfoAge Museum.*

per second). The radio wave bounced back just two and a half seconds later. This experiment proved that man could communicate across space and signaled the birth of the field of radar astronomy.

SCORE

After the launch of Russia's Sputnik on October 4, 1957, America's satellite efforts were similar to Russia's or failures. Finally, the United States achieved the successful launch of SCORE (Signal Communications by Orbiting Relay Equipment) on December 18, 1958. Developed as a top-secret project at Camp Evans by the U.S. Army Signal Corps, SCORE operated for thirty-five days. It proved that satellites could receive signals from one location on earth and immediately retransmit to another, as well as receive a signal, store it on an onboard recorder and then transmit on command from the ground. These technical accomplishments provided the basis for future communications satellites.

SCORE (Signal Communications by Orbiting Relay Equipment), launched on December 18, 1958, proved that satellites could receive signals from one location on earth and immediately retransmit to another, as well as receive a signal, store it on an onboard recorder and then transmit on command from the ground. *Courtesy of InfoAge Museum.*

SCORE had an immediate public impact: President Eisenhower presented a Christmas message of goodwill and peace through SCORE that was beamed to countries around the world. The mission achieved another first: placing an entire Atlas missile into earth orbit, a test of the rocket for military and space exploration uses. SCORE flew mounted in the nose cone of the Atlas.

SOLAR CELLS TO POWER SATELLITES

Hans Zeigler, a former Nazi scientist who came to the United States in Operation Paperclip, led the team that created solar cells to power satellites. (Operation Paperclip was a secret program in which over 1,600 German scientists, engineers and other experts, such as Wernher von Braun, were recruited for U.S. government employment at the end of World War II; many were members and some were leaders of the Nazi Party.)

GLASS FOR FIBER-OPTIC LINES

Working with Corning Glass of Corning, New York, Fort Monmouth scientists created the specifications to produce fiber-optic lines, which are vital for the internet.

LIGHT-EMITTING DIODES (LED)

Kurt Lehovec, a Czechoslovakian scientist who came to the United States after World War II in Operation Paperclip, explained the first light-emitting diodes, the photovoltaic effect in a solar cell and p/n junction isolation in microchips, which helped lay the groundwork for semiconductor technology. This patent was assigned to Sprague Electric. Because Lehovec was under salary with Sprague, he was paid only one dollar for this invention. Integrated circuits are used in virtually all electronic equipment today and have revolutionized the world of electronics. Computers, cell phones and other digital appliances are now inextricable parts of the structure of modern societies, made possible by the low cost of production of integrated circuits.

6

QUIRKY CREATIONS AND FIRSTS

FIRST ALMOST COMPLETE DINOSAUR SKELETON UNEARTHED: WILLIAM PARKER FOULKE

In the summer of 1858, William Parker Foulke was vacationing in Haddonfield when he heard that twenty years earlier, workers had found gigantic bones in a local marl pit. His neighbor, John Hopkins, had been digging in the marl (a nutrient-rich clay used as fertilizer) when he had found the bones. He no longer had them, but Foulke persuaded him to search again.

They hired a crew of diggers and, about ten feet down, found the bones of an animal larger than an elephant with features of both a lizard and a bird. These large, black bones had darkened due to the presence of iron and made up the left side of a skeleton. The bones included part of the hip, nearly all of the legs, twenty-eight vertebrae and nine teeth. Each bone was sketched, measured, wrapped in cloth and taken in a straw-filled cart to Foulke's home almost a mile away.

The word *dinosaur* had been coined only seventeen years earlier, but Foulke, a member of the Academy of Natural Sciences, was quite familiar with the creatures.

He had discovered the first nearly complete skeleton of a dinosaur. Dr. Joseph Leidy, a leading vertebrate paleontologist, examined the bones and named the find after Foulke: *Hadrosaurus foulkii*. The bones showed that the dinosaur was taller than a house and walked upright on two legs.

The bones were officially presented to the Philadelphia Academy of Natural Sciences in December 1858, where they remain today. (The museum is now called the Academy of Natural Sciences of Drexel University.)

FIRST COLLEGE FOOTBALL GAME

On November 6, 1869, Rutgers and Princeton played the first college football game on land now occupied by the gymnasium in New Brunswick, New Jersey.

Rutgers won the first game by a score of 6–4. Two teams of twenty-five men each played, using rules that were similar to rugby. The ten-inch round rubber ball could be advanced only by kicking it or striking it with the fist. The Rutgers men wore scarlet turbans. In the words of one of the players, the game was "replete with surprise, strategy, prodigies of determination, and physical prowess."

After graduation, the two captains achieved success in their careers. Princeton's William Gummere went on to become chief justice of the New Jersey Supreme Court, and William Leggett of Rutgers was ordained a minister in the Dutch Reformed Church.

THE FRANCIS LIFE-CAR: JOSEPH FRANCIS

This life-car, patented by Joseph Francis in 1845, was one of the most successful life-preserving devices developed at the time. Buoyant and pod-shaped, the metal life-car was used to rescue shipwreck victims when the vessel was foundering near land.

While standing on the beach, a person from a lifesaving station used a cannon-like gun to shoot sturdy lines out to the ship. The lines would then be tied to the ship's mast. The life-car was attached to, and pulled along these lines. Up to four people were bolted into the airtight compartment. They lay flat as they were hauled through the rough waters to the safety of the shore.

The Francis life-car was first used on January 12, 1850, to rescue the passengers on the stranded British bark *Ayrshire*. The ship, most likely filled with Irish immigrants fleeing the potato famine, ran aground on a sandbar off the New Jersey shore at Squan Beach, now known as Manasquan. A blinding snowstorm made the ocean too dangerous to launch a surfboat, the

Hadrosaurus was the first nearly complete skeleton of a dinosaur ever found. Dr. Foulke unearthed it in Haddonfield. *Courtesy of Dr. Richard Veit, Monmouth University.*

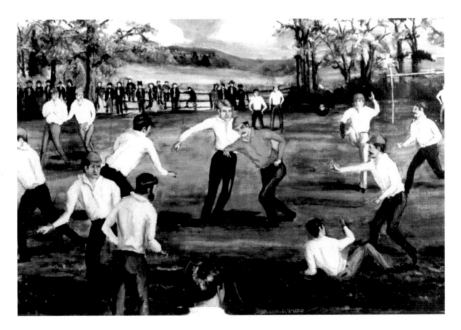

In 1869, Rutgers and Princeton played the first college football game. The stadium at Rutgers now boasts a sign that reads "Birthplace of College Football." *Courtesy of the Rutgers Libraries.*

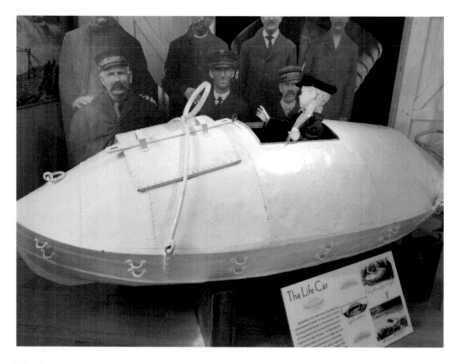

The Francis life-car was used to rescue shipwreck victims when the vessel was foundering near land. *Courtesy of Tuckerton Seaport.*

usual method of rescue, so local lifesavers decided to use the newly installed experimental life-car. Although never tested in an actual emergency, the Francis life-car performed as envisioned.

Out of 166 passengers and 36 crew members on the *Ayrshire*, only 1 was lost, perhaps needlessly, in the short journey from ship to shore. A male passenger insisted on riding on *top* of the life-car while his family inside was hauled to safety. He could not hold on and was washed away by the surf. Over the next three years, this device rescued at least 1,400 people on the New Jersey shore alone, as well as countless amounts of valuable cargo. The original, groundbreaking life-car used in the *Ayrshire* wreck was donated to the Smithsonian Institution by Joseph Francis in 1885.

THE FIRST AFRICAN AMERICAN MAN TO VOTE AFTER THE PASSAGE OF THE FIFTEENTH AMENDMENT: THOMAS MUNDY PETERSON

The City of Perth Amboy presented this medal to Thomas Peterson in 1884. *Courtesy of John Kerry Dyke.*

On March 30, 1870, the Fifteenth Amendment to the U.S. Constitution became law. It read, "The right of citizens of the United States to vote shall not be denied or abridged by the United States or by any state on account of race, color, or previous condition of servitude."

On the following day, March 31, 1870, the City of Perth Amboy held an election to determine whether the city charter should be revised or the city should become a township. Several people reminded Thomas Mundy Peterson that he was now allowed to vote, so he went home, had lunch, walked to the polling place and voted.

The following month, an African American man in Princeton, New Jersey, voted and was given a medal to commemorate that event.

Hearing that, the town fathers of Perth Amboy decided to do the same for Peterson. Fourteen years later, on Decoration Day in 1884, Thomas Mundy Peterson was presented with his medal. It now resides in Xavier University of Louisiana in New Orleans.

CROSSWORD PUZZLES: ARTHUR WYNNE

Have you ever wondered how the first crossword puzzle came to be? Well, you can thank Arthur Wynne of Cedar Grove, New Jersey.

Born in England, Arthur came to the United States in 1891 at the age of nineteen. He settled in Pittsburgh, where he worked for the *Pittsburgh Press* and played the violin in the Pittsburgh Symphony Orchestra. Moving to the East Coast, Arthur bought a home in Cedar Grove, New Jersey, an easy commute to his new job as the chief editorial writer for the *New York World*. Once a week, he created a puzzle page for the Sunday edition.

One day, his editor asked him to create a new kind of puzzle as a mental exercise. Remembering the "Magic Squares" game he had played as a child,

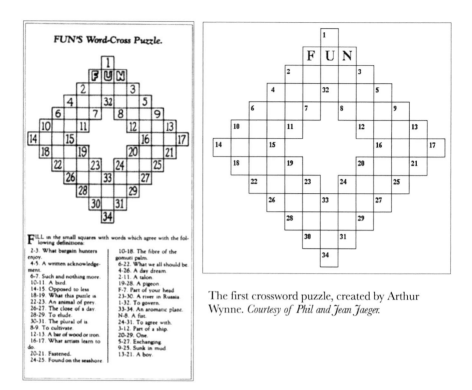

The first crossword puzzle, created by Arthur Wynne. *Courtesy of Phil and Jean Jaeger.*

Arthur made a larger, diamond-shaped grid and provided clues for the reader. His "word cross" first appeared in the *New York World* on December 21, 1913. A few weeks later, the typesetter accidentally reversed the words, and it's been a "crossword" puzzle ever since.

From that early beginning, the crossword puzzle has developed a huge following. Many devoted fans attempt the *New York Times* puzzle every day. The year 2018 marks the forty-first annual American Crossword Puzzle Tournament, held in Stamford, Connecticut.

THE MORRIS CANAL:
THE MOUNTAIN-CLIMBING WATERWAY

The Morris Canal was an engineering marvel. As it crossed New Jersey's Highlands, the canal overcame more elevation change than any other transportation canal ever built. The summit level is 914 feet above sea level, fed from Lake Hopatcong. As vessels plied its 102-mile length, they overcame elevation changes totaling 1,674 feet.

To accomplish this feat, the engineers used twenty-three inclined planes in addition to twenty-three lift locks. The planes were water-powered, using the water from the upper level of the canal to power a drum around which a Roebling wire rope cable was wrapped. The cable extended down the plane between a set of tracks, around a shive/pulley under the water at the bottom and back up the incline into the powerhouse. A canal boat glided onto a cradle car (or plane car) attached to the cable. At a signal, the plane tender opened a valve, allowing water from the upper level to drop through a penstock and into the turbine. As the turbine spun, the gearing turned the drum and the plane car began to move, carrying the boat and the cradle up the plane. Boats descending the plane followed the same procedure.

Digging began in 1825, and the canal opened for business in 1831, taking vessels as far as Newark, New Jersey, on the Passaic River. By 1836, the waterway was completed to Jersey City.

The Morris Canal was constructed to carry Pennsylvania's anthracite coal from Phillipsburg on the Delaware River to Jersey City on the Hudson River, opposite New York City. En route, the coal was delivered to northern

The long wooden flume carries water from the canal at the top of the plane into the powerhouse. The cable, held up by small pulleys, lies between the rails. The view shows Plane 7 West outside of Washington Borough. *Courtesy of the Library of Congress.*

New Jersey's iron furnaces, reviving the iron industry. Additionally, the canal boats carried farm products, manufactured goods, raw materials, stone and many other types of cargo.

The mountain-climbing Morris Canal is world famous for its many inclined planes. Its successful engineering was replicated for waterways in Japan, Nova Scotia and Poland.

SMOKELESS GUNPOWDER: HUDSON MAXIM (1853–1927)

While still in his twenties, Hudson Maxim formulated a hypothesis about the compound nature of atoms. He theorized that all matter is one and that the difference in the various forms of matter is due to the difference in the relative positions of the ultimate atoms. This was later proven by Einstein and accepted by the scientific community.

After a stint in the publishing business, Maxim began inventing and experimenting with ordnance and explosives. In 1890, he built a dynamite and smokeless powder mill in Maxim, New Jersey, near Farmingdale in Monmouth County. Here he developed and made the first smokeless gunpowder to be accepted by the U.S. government. He sold the business to the chemical firm E.I. duPont de Nemours Powder Company of Wilmington, Delaware. DuPont hired him as a consulting engineer.

In 1901, Maxim sold to the government the secret of his high-explosive material, Maximite, the first high explosive successfully used as a bursting charge for armor-piercing projectiles. It was even effective in wet conditions. He also invented a detonating fuse for high-explosive projectiles.

Later he invented stabilite, another smokeless gunpowder. It can be used as soon as it's produced, unlike those that require several months to dry. At the same time, he created motorite to drive torpedoes. The bars of motorite are coated on the outside and sealed into steel tubes. The bar is then ignited, and water is forced into the combustion chamber. The flame converts the water to steam, and the combustion and steam produce a fluid to drive a turbine or other engine.

In 1915, Maxim was appointed to the important Naval Consulting Board, which helped update America's military technology. He also served as chairman of the committee on ordnance and explosives and donated several inventions to the government.

Right: Hudson Maxim developed many explosives, including smokeless gunpowder. *Courtesy of Martin Kane.*

Below: Hudson Maxim's Venetian-style boathouse was one of the most photographed structures on the lake. *Courtesy of Martin Kane.*

Hudson Maxim didn't just invent explosives. He created a game of skill called the War Game, an improvement, he said, on the game of chess. He also authored *The Science of Poetry and the Philosophy of Language*, published in 1910.

In 1901, he visited Lake Hopatcong while doing work for the American Forcite Powder Works at Landing, on the southern end of the lake. Maxim and his wife bought significant land at the lake and became full-time residents there in the 1910s. While living at the lake, Maxim entertained frequently, inviting many prominent guests to his home. These included Thomas Edison, Rex Beach, Edwin Markham and Annie Oakley. His spectacular Venetian-style boathouse was one of the most photographed structures on the lake.

Lake Hopatcong was the main source of water for the Morris Canal. During times of drought, when the canal operation demanded water, the level of the lake was considerably lowered, leaving boat docks sitting on mud flats and causing much consternation among the residents. This led to Maxim leading the efforts for the abandonment of the Morris Canal, an effort that succeeded in 1924.

In 1910, Maxim and his wife acquired 650 acres in the borough of Hopatcong and were instrumental in the borough's development.

THE CREATOR OF TIME ZONES: WILLIAM F. ALLEN

From the beginning of the railroad era, time was kept by the sun. For every thirteen miles that a person (or a train) moved westward, he had to set his watch or clock back a minute. When it was noon by the sun in New York, it was 11:58 a.m. in Trenton and 11:56 a.m. in Philadelphia. This made catching a train tricky, since the time was figured differently in cities and towns along the railway.

In 1869, Professor C.F. Dowd of Saratoga, New York, announced his plan to divide the country into four time zones along the 75^{th}, 90^{th}, 105^{th} and 120^{th} lines of longitude. William F. Allen of Bordentown became the secretary of the General Time Convention in 1875 and worked on a new time plan. After the Allen family moved to South Orange, Allen carefully moved his watch ahead one minute as he commuted to New York and back a minute for the evening trip.

Finally, in an effort to end the confusion, all of the railroads in the country announced that on November 18, 1883, time would follow William Allen's

plan, which roughly followed that of Professor Dowd. In the 75th meridian zone (today's Eastern Time Zone), from Maine to just west of Pittsburgh, it would be noon everywhere when the sun crossed the 75th longitude (which passes through western New Jersey).

This change was not a law, as Congress didn't pass the Standard Time Act until 1919. It was simply announced by the railroads, and churches, towns and newspapers could use it or not. In fact, the attorney general of the United States warned that federal agencies could not accept the Allen plan. So it was, as John Cunningham relates in the *New Jersey Sampler*, that the attorney general went to Washington's Union Station to catch a train on November 18. "He was on time, by the sun, but 8 minutes and 20 seconds too late by the new railroad time. Time, or Mr. Allen's version of it, waited for no man. The Attorney General's train had left."

LUCY THE MARGATE ELEPHANT

What could attract prospective buyers to South Atlantic City? For James V. Lafferty, the answer was a sixty-five-foot-tall elephant.

In 1881, Lafferty shipped in wood, nails and bolts by boat and hired Philadelphia architect William Free to design his elephant. A Philadelphia contractor constructed the huge pachyderm as Lafferty's real estate office with legs ten feet in diameter and twenty-two feet high, a body thirty-eight feet long and eighty feet in circumference and a head twenty-six feet long and fifty-eight feet around. Then he added a tail that was twenty-six feet long, a trunk thirty-six feet long, seventeen-foot-long ears, two tusks each twenty-two feet long and eyes that were eighteen inches across. All of that was covered in twelve thousand square feet of sheet metal. Finally, Lafferty had the elephant painted white.

Lafferty received patent number 268,503 from the U.S. Patent Office on December 5, 1882, after he explained that his invention consisted of "a building in the form of an animal, the body of which is floored and divided into rooms…the legs contain the stairs which lead to the body."

Someone named it Lucy, and the elephant attracted many visitors, some of whom even bought property at the shore. As the population grew, the town fathers decided to break away from Atlantic City and call their new town Margate.

Lafferty designed two other elephants. The Light of Asia, a 40-foot wooden elephant built near the beach in what is now the Borough of

Lucy the Margate Elephant is a sixty-five-foot-tall structure on the beach. It never was a hotel, but postcards are notoriously wrong; this one gives the height as eighty-five feet, which is incorrect. *Courtesy of the Margate City Public Library.*

South Cape May, was torn down in 1899; and Elephantine Colossus on Coney Island, said to have been 122 feet tall with seven floors of exhibits, burned in 1896.

Eventually, the real estate baron overextended himself and offered his elephant and other property for sale. The buyer was Anton (Anthony) Gertzen of Philadelphia, who had spent many vacations in South Atlantic City and decided to settle there and establish a sport fishing business. Upon Gertzen's death, his property was divided among his children.

Son John Gertzen bought Lucy and other properties from his mother and charged visitors ten cents to tour the interior and climb the spiral stairs to the howdah. John and his wife hired Hattie Pfeil as their children's nurse, and she became the first tour guide for Lucy. Notable visitors who signed the guest register included opera and stage stars, foreign dignitaries, Vincent and John Jacob Astor, the duPonts of Delaware, Henry Ford, a young lawyer from Virginia named Woodrow Wilson and even the Rajah of Bhong and his wives from Singapore.

In 1902, an English doctor created a seven-room apartment inside Lucy for the summer. The next year, a storm severely damaged her; volunteers

dug her out of the sand and moved her farther back from the sea. She briefly served as a tavern, but rowdy customers knocked over the oil lamps and Lucy nearly burned to the ground in 1904.

In 1944, a hurricane devastated the Jersey coast. Lucy took a beating but somehow survived. Other nearby properties, including the entire Margate Boardwalk, were destroyed. In 1970, the Gertzens donated Lucy to the City of Margate, sold the land to developers and retired to Florida.

In 1969, the Margate Civic Authority was formed to find a way to save Lucy. Restoration architect John Milner examined the elephant to see if it could withstand the move to a city-owned lot two blocks away. He determined that it was structurally sound and would survive the move. The Save Lucy Committee hired the house-moving firm of Mullen and Ranalli for $9,000 to prepare the elephant. Feriozzi & Sons prepared a specially designed foundation at the new site for $15,000. Save Lucy had only thirty days to raise the money. The committee hosted a series of fundraising events, including a door-to-door campaign visiting every home in Margate. Despite of all its efforts, the committee was $10,000 short of its goal as the deadline for the move approached. To save the day—and the elephant—chairladies Josephine Harron and Sylvia Carpenter signed a personal note with the help of an anonymous co-signer, providing the means to proceed.

Monday, July 20, 1970, was moving day. But a sudden setback threw a wrench into the plans. The developer who owned the land adjacent to where it would soon stand filed an injunction to prevent the relocation of Lucy, claiming that the structure's presence would deflate his property values. A hearing was scheduled for exactly one day after the thirty-day deadline. The committee made a desperate appeal to Atlantic County judge Benjamin Rimm. After listening to arguments from both sides, Judge Rimm dissolved the injunction and ruled in favor of the Save Lucy Committee.

So, on Monday, July 20, one of the strangest processions ever witnessed in New Jersey began. A small yellow pickup had the power to tow this six-story, ninety-ton structure.

Eventually, the Save Lucy Committee received nonprofit corporate status, allowing it to seek grants. On September 8, 1971, Lucy was placed in the National Register of Historic Places. Restoration work began, and by the summer of 1974, a ribbon-cutting was held and visitors were welcomed.

During Lucy's second year, a guest who had been sailing to New York Harbor to see the Tall Ships saw Lucy from afar, moored his ship in Atlantic City and taxied to Margate for a tour. He introduced himself as Irénée du Pont Jr. from the famous E.I. du Pont de Nemours and Company of

Wilmington, Delaware. He made the fantastic offer to donate a sophisticated fire-suppression system for inside Lucy's wooden body, an important gift to protect a wooden structure. While on the tour inside Lucy, he recognized his sisters' and cousins' names on an old 1916 guest register. They had been visiting their grandmother, who owned a summer home in the neighboring community of Ventnor City.

By 1976, Lucy's metal skin and new ornate howdah were in place and freshly painted. The U.S. Department of the Interior recognized Lucy as a National Historic Landmark.

THE JERSEY JUMPER: SAM PATCH

On September 30, 1827, a mill worker stripped to his underwear atop the Great Falls of Paterson and jumped seventy feet into the Passaic River, just for the fun of it. Onlookers were dumbstruck that day as twenty-year-old Sam Patch emerged safely from the whirling water at the base of the falls. The next summer, he jumped over the falls two more times. He received thirteen dollars for the July 4 jump and fifteen dollars on August 2.

Sam Patch started his jumping career at the Great Falls of the Passaic River in Paterson, New Jersey. *Author's collection.*

But Sam Patch wasn't finished. "The Yankee Leaper" or "The Jersey Jumper" kept jumping for two more years. His biggest leap came on October 7, 1829, when hundreds gathered at Niagara Falls to see America's foremost daredevil toss a kiss to the ladies before becoming the first to survive a leap over the falls. The *Saturday Evening Post* said that he had "performed an act so extraordinary as almost to appear an incredible fable. Sam Patch has immortalized himself." So he leaped again a few days later.

Before crossing the Atlantic to jump from London Bridge, he decided to head for Rochester's Genesee Falls in late 1829. On November 6 (a cold month in New York State), ten thousand people watched him jump. After receiving so much acclaim, he wanted to jump there one more time. So, on Friday, November 13 (not superstitious, we suppose), he leaped again, and partway down, his body became limp and belly flopped into the water ninety-six feet below. His body finally emerged on St. Patrick's Day the following spring, encased in ice.

Sam's slogans were "Some things can be done as well as others" and "There is no mistake in Sam Patch." But it seems that there had been one.

FIRST STEAM-POWERED BOAT: JOHN FITCH

Born on a farm in Connecticut in 1743, John Fitch held many jobs, including those of shopkeeper, sailor, clockmaker and brass-maker. Seeking a fresh start after a failed marriage, he moved to Trenton, New Jersey, in 1769 and operated a brass-making and silversmith enterprise until the British arrived during the American Revolution. He served in the New Jersey militia and then worked as a gunsmith, a silversmith and a sutler, selling beer and tobacco to the Continental army.

After the war, Fitch surveyed the Northwest Territory for the State of Virginia and bought land, but he was unable to make any money from his landholdings.

At the age of forty-one he built a working model of a steamboat and then spent a year in search of financial, legal, political and scientific support for steam-powered travel. With no federal patent office yet in place, Fitch traveled from state to state, seeking patents. Finally, in New Jersey he was granted the exclusive right to build and operate steamboats on the state's waters for fourteen years. He quickly started a company, secured investors and partnered with Henry Voight, a Philadelphia clockmaker and mechanical genius.

In July 1786, Fitch successfully tested a new model and built a full-sized vessel. A year later, on August 22, 1787, Fitch unveiled his steamboat to the curious Philadelphians who stood on the banks of the Delaware River and watched the boat move upriver against the current at three miles an hour. Reportedly, delegates from the Constitutional Convention were among the onlookers and perhaps even passengers.

Following New Jersey's lead, Pennsylvania, New York, Delaware and Virginia then issued patents for the Fitch steamboat. His second vessel, sixty feet long and powered by a steam-driven paddle wheel, took passengers between Philadelphia and Burlington, New Jersey, in 190 minutes in 1788. Buoyed by this success, he built a third steamboat and, in 1790, offered passenger service on the Delaware River between Philadelphia, Bordentown, Burlington, Trenton and Wilmington, Delaware. With few passengers, however, the company failed.

Virginian James Rumsey also claimed to be the inventor of the steamboat. He had successfully sailed his steamboat on the Potomac River at Shepherdstown in 1787, a year after Fitch's demonstration on the Delaware. When the new federal patent office awarded patents to both Rumsey and Fitch for the invention of the steamboat, Fitch was angry that the board did not acknowledge that his vessel had been built and demonstrated first. He went to Europe in an unsuccessful search for backing. Returning to the United States, he built yet another vessel, a screw-propeller steamboat, but no one was interested.

New York politicians transferred Fitch's "exclusive grant" to the powerful Robert Livingston, who would later work with Robert Fulton and promote the story that Fulton had invented the steamboat.

Fitch died in Kentucky in 1798.

FIRST TELESCOPES DESIGNED FOR CELESTIAL PHOTOGRAPHY: LEWIS MORRIS RUTHERFURD

Although trained as a scientist during his studies at Williams College (Williamstown, Massachusetts), Lewis Morris Rutherfurd later became a lawyer. In 1849, he gave up his practice and traveled to Europe because of his wife's health.

He had maintained an interest in science and, while in Europe, met Italian astronomer Giovanni Amici, who was working on achromatism in microscopes—that is, one that gives images practically free from extraneous

The Lewis Rutherfurd refractor is shown here in September 2012. *Author's collection.*

colors. Rutherfurd performed pioneering work in spectral analysis and experimented with celestial photography. He invented instruments for his studies, including the micrometer for measuring photographs, a machine for producing improved ruled diffraction gratings and the first telescope designed specifically for astrophotography. Using his instrumentation, he produced a quality collection of photographs of the sun, moon and planets as well as stars and star clusters. In 1862, he began making spectroscopic studies using his new diffraction grating. He discovered distinct categories of spectral classes of stars.

By 1880, his lab was dismantled. He left New York City and spent his remaining years at the family's rural estate in Allamuchy, New Jersey. His ancestors had named the estate Tranquility. His health began to fail in 1887, and he died on May 30, 1892, at the age of seventy-six. He is buried in the Rutherfurd family plot, Tranquility Cemetery, New Jersey.

The Rutherfurd Crater was named for astrophotographer Lewis Morris Rutherfurd.

Tranquility is now called Rutherfurd Hall. It is owned and managed by the Allamuchy Township School District and is used as a community education and cultural facility.

FIRST INDIAN RESERVATION IN THE UNITED STATES: BROTHERTON

The first Indian reservation in the United States opened on August 29, 1758, in Shamong Township, Burlington County, New Jersey. Brotherton, the three-thousand-acre enclave, was built for the local Lenape (sometimes called the Delaware) tribes. Governor Francis Bernard promised that New Jersey would help the Indians move, erect buildings and see that the residents lived there in honor. None of those promises were honored, however, and the two hundred or so members of the Lenape tribe began a downward spiral, homesick for their earlier freedom.

Left: One of the few reminders of the Brotherton reservation is this historic marker, placed here by the New Jersey Archeological Society in 1958. *Courtesy of Douglas McCray.*

Below: The Indian Mills Fire Department commemorates in its name the site of the first Indian reservation. *Courtesy of Douglas McCray.*

The missionary John Brainerd arrived to supervise the reservation and used his own money to build a log church. A few Indians dammed a stream and built a sawmill and a gristmill, giving the place its new name of Indian Mills.

The Lenape asked permission of New Jersey to sell the Brotherton property in 1801. Permission was granted, and many moved to New York State, having been invited by the Oneida. Others moved to what are now Wisconsin and Ontario, Canada. Still others joined Cherokee and Osage people in the Indian Territory of what is now Oklahoma.

Today, near the former location of Brotherton, are a few establishments with "Indian Mills" in their names and a state historic marker.

FIRST COUNTY PARK IN THE UNITED STATES: BRANCH BROOK PARK

In 1895, Branch Brook Park became the nation's first county park. Located in Newark and in Belleville, New Jersey, the park is four miles long and encompasses 360 acres.

Branch Brook Park contains over four thousand cherry trees, the largest such collection in the country. They were a gift from the Felix Fuld family in 1927. The Cherry Blossom Festival in April attracts over ten thousand people a day.

Once containing a Civil War army training ground, the Blue Jay Swamp and a reservoir, the land was transferred to the Essex County Park Commission in July 1895. By 1900, the swamp had become a lake, flower gardens and expanses of lawns. The architectural firm of John Bogart and Nathan F. Barrett was hired to provide plans and advise for development of the park. They chose a Romantic style, dominated by geometrical gardens and arbors. But soon the firm of Frederick Law Olmsted was retained to revise the original plans for the park. It was refined into more naturalistic lines with gracefully curving paths and roadways. Between 1924 and 1929, the park doubled in size with donations from the Bamberger family and other residents of Newark.

In 1980, Branch Brook Park was placed in the New Jersey Register of Historic Places, and the following year in the National Register of Historic Places.

WAMPUM: CAMPBELL FAMILY OF PARK RIDGE

The Campbell clan was not the first family to make wampum for the Indian trade, but they were the most successful. Individual farmers shaped clamshells in their homes, but it was the Campbells who really made a business of the wampum trade. From 1775 until the mint closed in 1889, five generations of Campbells controlled the shell business in the Pascack Valley. In the third generation, Abraham Campbell began doing business with John Jacob Astor, who used wampum to trade for furs with Indians as far west as Oregon.

The family produced wampum in special shapes: "moons," "pipes" and miscellaneous beads. Moons were circular bits cut from conch shells, up to six inches in diameter. Five could be hung on a piece of red thread and sold for $3.50 in American dollars. Pipes were one to six inches in length. Beads were the leftovers from the manufacturing of the other two.

James Campbell of the fourth generation invented a water-cooled machine capable of drilling six pipes at once, turning out more than four hundred a day.

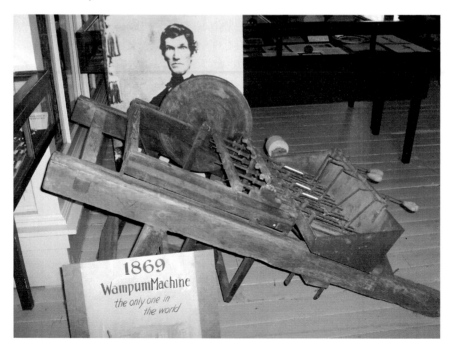

The Campbell clan was not the first family to make wampum for the Indian trade, but it was the most successful. Here is a view of one of their machines. *Courtesy of the Pascack Valley Historical Society.*

SKEE-BALL: JOSEPH F. SIMPSON

In the early 1900s, Joseph F. Simpson of Vineland created several inventions: an egg crate that could protect shells and a trunk clasp that kept luggage tightly shut. But his longest-lasting creation is a staple of the Jersey Shore boardwalk.

It's a ramp with holes at the far end. Players roll a ball up the ramp, over a bump and into one of the holes, each of which has a point value. Simpson named it Skee-Ball because it reminded him of SKEE (ski) hills and SKEE jumps.

He applied for a patent in 1907 and received it the next year. Although his game became popular along the Atlantic City Boardwalk, in Philadelphia and across the country, Simpson didn't profit; in fact, he suffered financial ruin. Eventually, people wouldn't even realize it was Simpson who had invented it.

Thaddeus Cooper and Kevin Kreitman, coauthors of *Seeking Redemption: The Real Story of the Beautiful Game of Skee-Ball*, found Simpson's 1908 patent in the archives of the Vineland (NJ) Historical and Antiquarian Society.

Princeton University alumnus J. Dickinson Este saw how popular the game was in the Philadelphia area and rented some space near Princeton. He installed a few games and decided to invest in Skee-Ball. By 1914, he owned all rights and began an aggressive marketing effort using his wealthy family's connections in the Pennsylvania news media. His ads might say, "Everybody is playing. Where have you been?"

During the Depression, the owners shortened the length from over thirty feet to about half of that. Today, alleys are about ten feet long. The shorter length attracted more players to the game. People enjoyed rolling their nine balls down this shorter alley and sinking them for prizes or tickets redeemable for prizes.

At some point, Este sold his interest to his partners, and by 1935, Skee-Ball was owned by the Wurlitzer company. Seeing the game's popularity, the jukebox maker increased production and produced five thousand machines in 1937 alone.

In 1945, the Philadelphia Toboggan Company purchased Skee-Ball and owned it for forty years. Joe Sladek purchased the game in 1985. Each owner has pursued Skee-Ball as a result of its considerable longevity and appeal, even though some local administrations have occasionally taken issue with the devices and their loose flirtation with gambling.

Randall Gabrielan enjoys a game of Skee-Ball. *Courtesy of Randall Gabrielan.*

"I know at some point in Chicago some cops came in and chopped Skee-Ball machines apart with axes, then tossed them out the back door," said Cooper.

Remarkably, Skee-Ball has remained largely unchanged for the past 110 years. Cooper noted that Simpson's early concept designs strongly resemble today's machines. It's still a very analog experience: pitch the ball and hope you hit a high-scoring target.

In 2016, Skee-Ball changed hands once more, this time to the Bay-Tek company. It's estimated that more than 125,000 machines are in operation today, with many locations organizing loose tournaments. Brewskee-Ball has made a name for itself as a leading competition league. Players can—and usually do—drink while playing, with winners receiving cream-colored jackets and trophies as proof of their Skee-Ball prowess. Like roller derby participants, they favor colorful player names like Brewbacca and Monica LewinSkee and play during "skeesons." (Back in March, Brewbacca was the focus of an ABC News digital feature.)

While some machines dating back to the 1940s are still in operation in a few locations, Cooper says he and Kreitman have yet to come across any of the original models from either Simpson or Este.

Simpson died in 1930, living long enough to see Skee-Ball become a popular pastime but unable to reap the financial rewards he had worked so hard to try and achieve.

"He was fifty-seven when he invented it," noted Kreitman. "He saw the success, but never saw the financial benefits."

TWIN LIGHTS FIRSTS

Twin Lights in Highlands, New Jersey, is one of the most distinctively designed lighthouses in the world, with its two towers, one octagonal and one square. This site is home to not just one or two New Jersey firsts but five.

1. Twin Lights was the first lighthouse to use the Fresnel (freh-nel) lens. Designed by French physicist Augustine Fresnel, this lens resembles a glass beehive. Its design reduces the amount of material required—compared to a conventional lens—by dividing the lens into a set of concentric ring-like sections.

2. On April 25, 1893, at Twin Lights, the Pledge of Allegiance was recited for the first time. Slightly different from today's wording, the pledge read: "I pledge allegiance to my flag and to the Republic for which it stands, one nation, indivisible, with liberty and justice for all."

Two years earlier, Newark businessman William McDowell announced his plan to erect the tallest flagpole on the highest spot along the Atlantic coast to commemorate the 400th anniversary of Columbus's arrival. He wanted this Liberty Pole to be the first thing that travelers saw as they approached New York harbor.

Hundreds of people gathered at the base of the 135-foot flagpole and recited the pledge in one of the most patriotic events of the 1890s.

3. In 1899, Guglielmo Marconi installed an antenna and receiving station at Twin Lights to demonstrate his invention: the wireless telegraph. The inventor had been hired by *New York Herald* publisher James Gordon Bennett to attempt a ship-to-shore report of the America's Cup yacht races off Sandy Hook. When Admiral Dewey's fleet arrived home early from its victory in the Philippines, the races were postponed, and Bennett asked Marconi to set up his wireless receiver in front of the lighthouse. Marconi sailed out to meet the fleet and radioed a report back to Twin Lights, making this the first commercial radio broadcast.

4. The first lifesaving station in America was established at Twin Lights. It was the first building for boats constructed and one of the few that still survive. According to Commander Timothy Dring, U.S. Navy Reserve (Retired), the structure at the Twin Lights is the only known example of the first federally established coastal life-saving stations created under the Newell Act of 1848:

"It is the last surviving building from a total of twenty-six lifesaving equipment boathouses that were constructed over the years 1848 to 1856, primarily along the coastlines of New Jersey and Long Island. In fact, the Spermaceti Cove boathouse was the very first one to be built and holds the distinct honor as the first federal lifesaving station ever built in this country. Moreover, the boathouse equipment artifacts that are in the collection at Twin Lights are the originals that were issued in 1849, making them the oldest surviving pieces of such equipment. As such, this boathouse and its artifacts are not only of local and state historical interest, but also national historical interest."

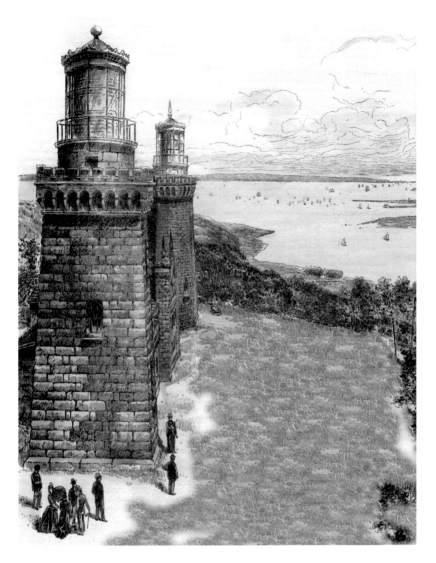

Twin Lights was the scene of five firsts in New Jersey history. *Courtesy of Mark Stewart, Twin Lights Historical Society.*

5. In 1935, the U.S. Army Signal Corps from Fort Monmouth began testing its radar at Twin Lights, a site chosen due to its location on the highest point on the Eastern Seaboard between southern Maine and the Yucatan peninsula in Mexico. Dubbed "mystery ray" by the press, radar proved to be a major development for the Allies during World War II. (See chapter 5 for more details.)

LIGHTHOUSES—SANDY HOOK AND ABSECON

Absecon Lighthouse Is the Tallest in New Jersey

Located at Pacific and Rhode Island Avenues in Atlantic City, Absecon is 171 feet tall, the third-tallest lighthouse in the United States.

During its construction, one of the engineers was Lieutenant George Meade, later the commander of the Union army at Gettysburg. The first lighting of the first-order Fresnel lens occurred on January 15, 1857; the light shone nineteen and a half miles out to sea. The light was electrified in 1925.

Absecon Lighthouse was decommissioned in 1933, and the light was extinguished. In 1963, Governor Richard Hughes pressed a button in the statehouse, relighting the lens for the first time in twenty-five years, for New Jersey's tercentennial celebration. In 1970, the lighthouse was added to the New Jersey Register of Historic Places.

Sandy Hook Is the Oldest Lighthouse in Continuous Use in the United States

In 1761, the merchants of New York City asked the provincial council to erect a lighthouse at Sandy Hook, as they had lost much money due to shipwrecks. The funds to purchase the land and construct the lighthouse came from the proceeds of two lotteries.

The lighthouse was built about five hundred feet from the tip of the hook. Today, due to the northward expansion of the hook, it now stands about one and a half miles from the point.

In 1883, the keeper received a new home, the dwelling that stands today. In 1889, the Sandy Hook lighthouse became the first lighthouse in the country to be lit by electric incandescent lamps.

In 1964, the lighthouse celebrated its 200th anniversary. At a ceremony celebrating this event, Walter I. Pozen, a New Jersey native and assistant to the Secretary of the Interior, dedicated the lighthouse as a National Historic Landmark.

The lighthouse and surrounding Fort Hancock are now part of the Gateway National Recreation Area. The lighthouse is still in active operation and is equipped with a third-order Fresnel lens illuminated by a one-thousand-watt bulb, emitting forty-five thousand candlepower. It is visible nineteen miles at sea.

In 1996, the ownership of the lighthouse was transferred from the U.S. Coast Guard to the National Park Service.

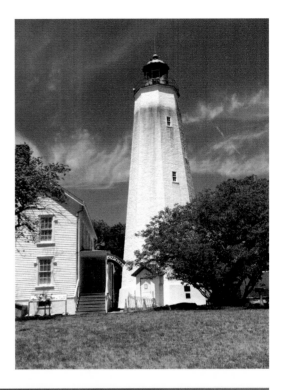

Right: Sandy Hook Light is the oldest lighthouse in continuous use in the United States. *Courtesy of William A. McKelvey, New Jersey Lighthouse Society.*

Below: Absecon Light is the tallest in New Jersey. *Courtesy of William A. McKelvey, New Jersey Lighthouse Society.*

THE AQUATIC VELOCIPEDE: LEWIS D. BUNN

Lewis Bunn, a Morristown undertaker, invented the aquatic velocipede, a pedal-powered vessel that he operated on the city's Lake Pocahontas. He is pictured on the following page with his half-brother, William Crane Burnett, and another gentleman.

According to Kevin Coughlin in "Bet You Didn't Know…Morristown at 150," Lewis Bunn also created Bunn's Improved Corpse Preserver. This 1866 invention was guaranteed to "preserve the body from decay for any reasonable length of time."

SOAP BUBBLE MACHINE: RUSSELL BORUS

While shopping at the New Egypt, New Jersey flea market, Russell Borus found the parts he needed to create a gasoline-powered soap bubble machine. A member of the Pineland Antique Engine Association, he has always enjoyed building engines. He gathered a few more items from the Rough and Tumble Historical Association in Kinzer, Pennsylvania, a group that helps preserve America's agricultural and industrial history. (The Rough and Tumble group has a huge collection of gasoline engines, including the oldest internal combustion engine running in North America; it was built by Otto and Langen in 1867. One building is filled with operating stationary steam engines.)

So Russell put together a drill press and the frame from a lathe. He used a kitchen whisk, flattened on the end, for the bubble wheel, which rotates through a basin of soapy water. An ordinary fan blows through the wheel, sending the soap bubbles out into the air. The machine is driven by a hit-or-miss gasoline engine with a three-inch-wide leather drive belt. The engine was purchased from a 1913 Sears Roebuck catalogue.

COLT PATERSON REVOLVER: SAMUEL COLT

Named for the New Jersey city where it was made, the Colt Paterson was the first modern revolving pistol. Colt's previous revolvers had failed so badly that, until February 1836, the U.S. Patent Office refused to give him a patent. Even the gun for which he received the patent had a few design flaws, including the problem that the trigger remained hidden until the gun was cocked.

Bunn's aquatic velocipede, a pedal-powered vessel on Morristown's Lake Pocahontas. *Courtesy of James Lewis, Morristown and Morris Township Library.*

This soap bubble machine was created by Russell Borus. *Courtesy of Russell Borus.*

Some investors set him up in business in Paterson, but instead of making guns, he followed in the footsteps of Eli Whitney and built machines that could produce interchangeable parts on an assembly line. Sam's investors told him to stop, make guns and travel around the country and sell them. He convinced them to build a four-story gun mill for him. Here he made many weapons and gave them away to world leaders. But leaders of the U.S. Army said his revolvers and pistols were useless.

Finally, during the Seminole Wars, General Thomas Jesup bought fifty Colt guns and paid him with a government draft for $6,250. Unfortunately, he lost it when his ship sank en route home. At last, Colt had to sell everything and close his Paterson factory.

Texas Ranger Sam Walker came north and asked Colt to make one thousand revolvers for the Mexican War, but Colt did not have even one model left. He designed a new one and convinced Eli Whitney to manufacture them. With this success, after years of having no money, he built a new factory in Hartford, Connecticut. His estate was worth $15 million when he died. The new model he sold to Walker had been nearly the same as the Paterson revolver.

HAMMOND'S YELLOW SPRING BEAUTIES: A FLORAL FIRST...AND ONLY

The Hammond's yellow spring beauty is a flower that grows in only *one* location in New Jersey and nowhere else on earth.

This rare wildflower is yellow and blooms all summer, unlike the common spring beauty, which is white and blooms in May. The Hammond's variety grows only in one meadow in the Garden State, and that specific location in the Kittatinny foothills is not open to the public. Known as the Arctic Meadows Preserve, it is home to black bears, beaver, coyote and bobcats.

Naturalist Emilie K. Hammond discovered this variety of spring beauty over fifty years ago. She saw that the flower looked like the common spring beauty, but it wasn't white and didn't have pink stripes on its petals. It is smaller than a dime and resembles a buttercup.

In the mid-1980s, she described the flower to David Snyder of the Nature Conservancy, who recognized that it was different from the common spring beauty in coloring and location. Now New Jersey's state botanist, Snyder worked with other botanists, conducting genetic testing. He is sure that this is a distinct variety.

Other plants that only grow in New Jersey are a blackberry bush in Cape May and a bog asphodel in the Pine Barrens.

MINERALS FOUND NO PLACE ELSE ON EARTH

At the Sterling Hill Mining Museum and the Franklin Mineral Museum, miners have found over 340 minerals—including zincite, willemite and franklinite—that are found nowhere else on earth—a world record for the number of minerals found in one area. In addition, the Franklin Mineral Museum is the fluorescent mineral capital of the world.

These two sites are home to the world's most famous zinc mines. Over the life of the mines, they produced 33 million tons of ore. Sterling Hill was first worked before 1739 and closed in 1986, after more than 138 years of almost continuous production. It was purchased in 1989 by the Hauck family to preserve the legacy of the mines. Franklin mine closed in 1954.

One of the most popular features of the site is the Thomas S. Warren Museum of Fluorescence, founded in 1999 and opened to the public in 2000. Named for inventor and collector Thomas Warren, the museum displays over seven hundred objects and uses exhibits, lectures and workshops to reveal the beauty and utility of fluorescence.

FIRST CALL USING AN AREA CODE

With our cell phones, it's possible to call anyone anywhere in the world. But before 1951, that wasn't so easy. We had to call the operator and ask her (it was usually a woman) to place the call for us.

But on November 10, 1951, the first direct-dialed, long-distance call was made. The mayor of Englewood, New Jersey, called the mayor of Alameda, California. This was only possible with the introduction of the area code as part of the new ten-digit phone numbers.

The system of area codes was developed by AT&T and Bell Laboratories and called the North American Numbering Plan (NANP).

FIRST THREE-WAY CATALYTIC CONVERTER: JOHN J. MOONEY

To clean up the smog in our country, as mandated by Congress in 1970, it was necessary to lessen the emissions from automobiles. These emissions contained hydrocarbons, carbon monoxide and nitrogen oxide.

There were earlier versions of a catalytic converter, but these could only remove two of the three elements of harmful emissions. Mooney and his partner Carl Keith developed the three-way converter in 1973 while working for the Englehard Corporation (now BASF). In 2002, they won the National Medal of Technology, awarded by the U.S. Patent and Trademark Office.

IMPROVEMENTS TO THE STREET SWEEPER: CHARLES BROOKS

A resident of Newark, Charles Brooks made improvements to the street-sweeping machine. In 1896, he added spinning brushes and a more efficiently designed container for the collected debris.

HANDICAP SYSTEM: LEIGHTON CALKINS

Leighton Calkins of Plainfield, New Jersey, was the creator of the Calkins Handicap System used in golf. In 1907 and 1908, he was a member of the executive committee of the United States Golf Association. In the same years, he served as president of the New Jersey Golf Association.

In 1905, Calkins introduced the Calkins System for Calculating Handicaps, which was adopted by the USGA in 1911. Handicaps were determined by averaging a player's three best scores and applying that average to Calkins's handicap table in the column under the par figure for the course played.

The Calkins Handicap Table took into account the difference between a player's average best scores and par, as well as the degree of improvement that could be expected of players at different handicap levels.

This system was generally discontinued in the late 1930s and early 1940s.

MORE NEW JERSEY FIRSTS

1789 New Jersey was the first state to ratify the Bill of Rights.
1884 Grover Cleveland was the first (and to date the only) president born in New Jersey.
1969 Montclair resident Edwin "Buzz" Aldrin became the first New Jerseyan to land on the moon.
1993 Christine Todd Whitman was elected as the first female governor of New Jersey.

THEY'RE FROM NEW JERSEY?

NEW JERSEY SIGNERS OF THE DECLARATION OF INDEPENDENCE

Abraham Clark (1725–1794), Lawyer

Abraham Clark was deemed too frail to work on the family farm in Elizabeth, so he was tutored in mathematics and surveying. The latter gave him an income while he studied the law. He often defended the little man who could not afford a lawyer and was known for his integrity and his character, successfully helping poor farmers in title disputes. He served as clerk of the Provincial Assembly and high sheriff of Essex County.

In 1748, Abraham Clark met Sarah Hatfield, who bore him ten children.

Clark pursued a career in politics and was elected to the Provincial Congress in 1775. He was sent as a delegate from New Jersey to the Second Continental Congress after the state replaced the previous delegates, who would not vote for independence from Great Britain.

Clark was a leading voice in New Jersey for independence and served in the Congress through 1778. Two of his sons were officers in the Continental army and were captured by the British, tortured and beaten due to their father's signature on the Declaration of Independence. Imprisoned in the notorious prison ship *Jersey*, Captain Clark was thrown into a dungeon and fed very little. His father learned of it and raised the issue to Congress. It was the only time that Abraham Clark mentioned

his sons who served in the army. The British responded by improving his conditions.

He retired from public service in 1794 and died of sunstroke that September. His epitaph reads:

Firm and determined as a patriot,
Zealous and faithful as a friend to the public,
He loved his country,
And adhered to her cause
In the darkest hours of her struggles
Against oppression

John Hart (1713–1779), Farmer

John Hart worked on his father's farm near Hopewell and began public service as a justice of the peace. He served for many years in the New Jersey Assembly and was a judge in the Court of Common Pleas. Elected to the Provincial Congress, he was sent to the Second Continental Congress, serving on the Committee of Safety.

Since he was a signer of the Declaration of Independence, Hart was sought by the British. His farm was looted, and he could not return home. He was forced to hide in the Sourland Mountains near Hopewell in the cold of November. After making arrangements for the safety of his younger children because his wife had just died, he may have lived under a rock outcropping or in the homes of friends. The mountains were impenetrable, and the British troops could not find him. In either case, he didn't return home until after Washington crossed the Delaware and turned the tide on the British.

In June 1778, as Washington led the Continental army from Valley Forge to Monmouth Courthouse, Hart offered his Hopewell Township farm as a camp for the army and invited Washington to stop for lunch.

John Hart died on May 11, 1779, at age sixty-six, a true patriot from what was then Hunterdon County.

Richard Stockton (1730–1781), Lawyer

Richard Stockton was born at Morven, the family home in Princeton. He graduated from the College of New Jersey in Newark in 1848. Some years

Richard Stockton, a Princeton lawyer, signed the Declaration of Independence. *Courtesy of the Princeton University Art Museum.*

later, his family donated money and land to the college to move it from Newark to Princeton, where it became Princeton University.

Trained as a lawyer, Richard Stockton had one of the largest practices in New Jersey. He opened a law office in Princeton in 1754 and another in Newark some time later. He was recognized as one of the most eloquent lawyers in the colonies.

Stockton was appointed to a seat in the Royal Executive Council of New Jersey in 1768 and became a judge of the New Jersey Supreme Court in 1774. He made several attempts to negotiate a plan to settle disputes between England and its American colonies, but in the end, he chose his country over his king and resigned from his royal appointments. His native state elected him to the Second Continental Congress in June 1776.

On July 1, he and the Reverend John Witherspoon rode through a rainstorm from Princeton, arriving in Philadelphia near the end of a speech by John Adams. Stockton asked Adams to repeat what he had missed, and the delegate from Massachusetts did so. After hearing the arguments for independence, Stockton agreed and voted in favor.

In the election for New Jersey governor in August 1776, Stockton and William Livingston received an equal number of votes. Stockton was not interested in being governor and was instead elected chief justice of the state, a position he also rejected, preferring to serve in the Continental Congress. He was reelected in November.

As the British invaded New Jersey, Stockton rushed back to Princeton and moved his family to a friend's home, thirty miles away. On November 30, Loyalists captured Stockton, dragging him clad only in a nightshirt and breeches into the cold night. They ransacked his home and turned him over to the British. He was jailed briefly in Perth Amboy and then locked up in the notorious Provost prison in New York City. Here he spent the winter of 1776–77, locked in irons, starving and shivering.

On January 3, 1777, after the Battle of Princeton, Congress directed George Washington to protest to General Howe about Stockton's treatment.

As a result, Stockton was paroled in mid-January after agreeing to no longer participate in the war effort (a common practice on both sides).

He returned home near death. As Morven had been the headquarters of British general Charles Cornwallis, Stockton found that his belongings, crops and livestock had been taken or destroyed. His fine library had been burned. A week later, his son-in-law and fellow signer Dr. Benjamin Rush wrote, "At Princeton I met my wife's father who had been plundered of all his household furniture and stock by the British army, and carried a prisoner to New York, from whence he was permitted to return to his family upon parole."

It has been said that Stockton took the pardon and swore allegiance to the king; however, the Society of the Descendants of the Signers of the Declaration of Independence offers this research to repudiate this claim:

> *This claim is based on a private letter quoting a rumor spread by an enemy of Stockton. There is absolutely no proof this occurred. In March 1777, only two months after Stockton's release, in a letter to the British Parliament, General Howe wrote "at no time had a leading rebel sought pardon."* The book, His Sacred Honor, *by John C. Glynn, Jr. and Kathryn Glynn, comes to Stockton's defense against these revisionist writers using rumors and innuendo to spread this false claim against a founding father.*

Richard Stockton was forced to accept help from his family and friends to survive. He resigned from Congress, slowly regained his health and returned to his law practice to support his family. He developed cancer and did not live to see his country win its independence. Stockton died on February 28, 1781. He was buried at the Stony Brook Quaker Cemetery in Princeton, New Jersey, among his Quaker ancestors.

John Witherspoon (1723–1794), President of the College of New Jersey

Born in Scotland, John Witherspoon received his theological training in Edinburgh. As a Presbyterian minister, he received his doctorate of divinity from the University of St. Andrews. Richard Stockton and Benjamin Rush were among the colonists who convinced Witherspoon to come to Princeton, New Jersey, to serve as the first president of the College of New Jersey.

The Reverend John Witherspoon was the president of the College of New Jersey when he signed the Declaration of Independence. *Courtesy of the Princeton University Art Museum.*

Under his leadership, the College of New Jersey (now Princeton University) thrived. Witherspoon came to support the cause of independence and was elected to the Continental Congress in 1776. During his tenure, he served on over one hundred committees and was a frequent debater.

In November 1776, Witherspoon closed and evacuated the college as the British approached. They occupied college buildings and did much damage.

Following the war, Witherspoon devoted his life to rebuilding the college. He served twice in the state legislature. In the last years of his life, he became totally blind. He died on his farm, Tusculum, just outside of Princeton in November 1794, a man much honored and beloved by his adopted countrymen.

Francis Hopkinson (1737–1791): First United States Flag

Many know Francis Hopkinson as one of the signers of the Declaration of Independence from New Jersey. He was, however, a man of many talents, studying law and writing music, poetry and satire.

Hopkinson had been the first student at the Academy of Philadelphia and received the first diploma from the University of Pennsylvania (then called the College of Philadelphia). He gave public harpsichord concerts, and his poetry was published in colonial magazines.

Over the years, Hopkinson served as the customs collector in Salem, New Jersey, and in New Castle, Delaware. His political satires and poems attacked and ridiculed British leaders. Among his works are "A Pretty Story," a satirical look at the relationship between Great Britain and the American colonies, and "Battle of the Kegs," another satire that taunted the British.

At the same time, he served the Continental Congress as chairman of the Navy Board and judge of the admiralty. His artistic talent led him to design coins and paper currency, as well as the Great Seal of the State of New

Francis Hopkinson signed the Declaration of Independence and designed our country's first flag. *Courtesy of Robert H. Barth.*

Jersey. In fact, the state assembly voted in 1777 to pay him for "expences of the Great Seal of this State."

He designed a naval flag that he later altered to become the first American flag. Though his political adversaries blocked all attempts to have him paid for his services, they never denied that he made the designs. The journals of the Continental Congress clearly show that he designed the flag. The first Stars and Stripes had the thirteen stars arranged in five rows of three, two, three, two and three.

After the Revolution, Hopkinson served as a judge in Pennsylvania, but he still had time to create an improved ship's log and devices for the harpsichord. In 1788, he published what may be the first book of music by an American composer.

He died of a massive epileptic seizure in 1791, at the still young age of fifty-three.

JOSEPH BONAPARTE (1768-1844)

Would you believe that Napoleon's brother was a New Jersey resident?

Since Napoleon Bonaparte had no heir, his eldest brother, Joseph, claimed that *he* had that role. Napoleon, however, wanted to recognize the son of Louis Bonaparte, his younger brother. Joseph was offered the position of king of Lombardy if he waived his claim to succession. Instead, he went to Naples and became the king of that kingdom.

Napoleon became unhappy with his brother's conduct and sent him to be the king of Spain. After Napoleon's surrender at Rochefort, the Bonapartes were banished from France and lost their property, income and civil rights. Joseph sailed incognito to New York and then went to Philadelphia. He bought over one thousand acres near Bordentown, using money from the sale of his millions in jewels.

He built an estate he called Point Breeze, but it was also known as Bonaparte's Park. His first mansion burned on January 4, 1820. Bonaparte was away but arrived in time to see the roof collapse. His Bordentown neighbors rushed to the property and rescued most of his artwork, furniture, silver and other valuables. Bonaparte later publicly praised their efforts in a letter written to local newspapers.

He then built a second, grander mansion, set farther back from the river, judged as the second-finest house in America, after the Executive Mansion. Bonaparte loved wine and dinner parties—his nickname was "Joey Bottles"—and Monmouth University students who participated in an archaeological dig unearthed generous evidence of this in the hundreds of broken wine bottles recovered at the site. The estate had several underground tunnels, which were used to bring in supplies and also offered a quick escape route if enemies came to call.

In 1839, Bonaparte left New Jersey for Europe, where he died in 1844.

SETH BOYDEN (1788-1870)

Seth Boyden invented the processes for making patent leather and malleable iron. Born in Massachusetts, he moved to Newark in 1815 to show his new leather-cutting machine to the city's leather makers; this machine could slit thick animal hides into thin slices. He let the leather makers have his new machine while he worked on a new way of silver-plating buckles and harness ornaments.

When that was successful, he began a new project: glazing leather to make a shiny surface. His efforts resulted in a glossy leather that quickly became popular in formal dress. He called this new product patent leather. Before Boyden, all leather was soft and highly bendable, but his invention was the hard, shiny leather that turned out to be excellent for boots. He had solved the problem of maintaining the durability of leather while allowing it to have a dressy appearance.

But Boyden was already bored. He could not stick to anything merely for profit. He wanted something new to experiment with. That something was malleable iron. He knew that cast iron could be heated until it became liquid and then poured into a mold to solidify. But Boyden wanted a way to shape iron so that it could be easily worked into more complicated forms than cast iron allowed. On Independence Day 1826, after much experimentation, he found the secret of malleable iron, and within a few days, he began production.

Again, Boyden quickly tired of his past enterprises and turned his attention to transportation. He built a six-ton locomotive, the *Orange*, that crossed the hills to the west of Newark in July 1837. Despite all of his inventions, Seth Boyden died in poverty in 1870. He had not applied for patents to protect his inventions because he thought that all such discoveries should be public property. This philosophy kept him a poor man but made others rich, as they used his creations.

Boyden also developed the forerunner of the American Process furnace grate bar, an inexpensive process for manufacturing sheet iron, and machines for manufacturing nails and cutting files. The hat-forming machine was the only invention for which he filed for a patent, and that was late in his life.

When asked why he didn't request a patent for patent leather, Boyden said, "I introduced patent leather, but it should be remembered that there was nothing generous or liberal in its introduction, as I served myself first, and when its novelty had ceased and I had other objects in view, it was a natural course to leave it."

Though he did not seek fame or riches, Boyden was greatly respected in his own lifetime. The Maplewood house in which he lived his last fifteen years was donated to him by grateful industrialists. That respect is reflected in the statue erected of him in Newark's Washington Park.

In 1926, an admiring and aged Thomas Edison said of Boyden at a ceremony at the Boyden statue, "He was one of America's greatest inventors....His many great and practical inventions have been the basis for great industries which give employment to millions of people."

Seth Boyden was inducted into the first class of the New Jersey Inventors Hall of Fame in 1989.

JAMES WILSON MARSHALL (1810–1885)

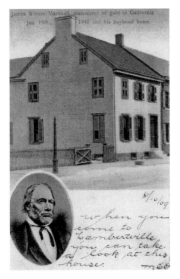

This postcard features James Marshall and his home in Lambertville, New Jersey. *Courtesy of Jeffrey McVey.*

Lambertville resident James Wilson Marshall headed west in 1834 when the family home was sold. He lived in Indiana and Illinois before settling in Missouri, where he contracted malaria. In the hope of improving his health, James joined a wagon train and arrived in the Willamette Valley in Oregon in 1845. He soon left Oregon and headed south to Sutter's Fort in California.

John Sutter hired Marshall, a carpenter, to work at his sawmill and helped him buy land and cattle. James left his ranch to fight in the Mexican-American War. He returned in 1847 to find that his cattle had strayed or been stolen. Having no income, James partnered with Sutter to build a new sawmill forty miles upstream on the American River. Construction continued into early 1848.

In an effort to enlarge the tailrace, Marshall decided to use the force of the river to excavate the ditch. He did this work at night—so as not to endanger the lives of the workers—and each morning examined the results. On the morning of January 24, he noticed some shiny flecks in the channel. In his words:

> *I picked up one or two pieces and examined them attentively; and having some general knowledge of minerals, I could not call to mind more than two which in any way resembled this, sulphuret of iron, very bright and brittle; and gold, bright, yet malleable. I then tried it between two rocks, and found that it could be beaten into a different shape, but not broken. I then collected four or five pieces and went up to Mr. Scott (who was working at the carpenter's bench making the mill wheel) with the pieces in my hand and said, "I have found it."*
>
> *"What is it?" inquired Scott.*
>
> *"Gold," I answered.*
>
> *"Oh! no," replied Scott, "That can't be."*
>
> *I said,—"I know it to be nothing else."*

After testing, the metal was confirmed to be gold. Marshall permitted his crew to search for more gold during their free time. When Marshall returned to the fort four days later, Sutter performed further tests and determined that it was gold "of the finest quality, of at least 23 karat."

Marshall's sawmill failed when his crew left to search for gold. Soon, hordes of prospectors forced him off his land.

Marshall did not personally profit from his discovery, but for four years (1872–76) he received a pension awarded by the California legislature in recognition of his role in the gold rush.

Today, there is a tomb and a monument to James Marshall, erected by the Native Sons of the Golden West. The statue on top shows Marshall pointing to the spot where he made his famous discovery.

THE MIDDLEBUSH GIANT (1824-1899)

Descriptions of the life of the Middlebush Giant are many and varied. It is sometimes hard to distinguish truth from fiction.

He was probably born Arthur James Caley on the Isle of Man in the Irish Sea, although P.T. Barnum fictitiously claimed Jerusalem as his place of birth. In his teens and twenties, he grew very tall, culminating in a height of seven feet, six inches, though some sources say seven feet, eleven inches. On a visit to the United Kingdom, Arthur exhibited himself in Manchester and London. At some point, Caley moved to the United States and adopted the name Colonel Routh Goshen.

By late 1863, he was exhibited at P.T. Barnum's American Museum, along with the dwarfs General Tom Thumb and Commodore Nutt, creating a popular tall and short act. In the 1870s and early 1880s, he toured with Barnum's New and Greatest Show on Earth. He is said to have been an advertising symbol for a Chicago clothing store known for having a "gigantic" selection of items. One story says that he retired in the 1880s and moved to the Middlebush section of Franklin Township, Somerset County. He lived on a farm there for fifteen years, until his death in 1899.

The giant's funeral attracted many gawkers, who wanted to see his casket. To accommodate his enormous size, the coffin was three feet across and eight feet long. Due to his weight of nearly six hundred pounds, it took many pallbearers to carry him to the wagon for the trip to Cedar Grove Cemetery. The giant had requested that his grave be deep, as he feared that someone might exhume his remains and exhibit them. While there is a marker in the cemetery, the exact location of his grave is a well-kept secret.

COL. RUTH GOSHON,
Age, 43 years. Weight, 620 lbs. Height, 7 feet 11 inches.
Bogardus, Photo. 872 Broadway cor 18 St NY

The Middlebush Giant. *Courtesy of the Franklin Township Public Library.*

EMANUEL NINGER (1845-1924)

Emanuel Ninger was quite an accomplished sign painter and artist—well, actually, more of a con artist.

This German immigrant and his wife arrived in Hoboken in 1876, settling on a farm in Westfield, New Jersey. In October 1892, he moved to the Flagtown section of Hillsborough, New Jersey. He didn't seem to be employed, but told his neighbors that he was receiving a pension from the Prussian army. He and his wife supplemented the pension by raising chickens and growing vegetables.

Ninger began copying U.S. currency, starting with tens, twenties and fifties, later moving on to $100 bills, using only pen, ink and brushes. Every month, he took the train to New York, where it was easier to pass the bills at small businesses; liquor stores were a favorite. Once in circulation, the bills were almost impossible to trace.

In November 1893, someone reported one of his 100s to the Treasury Department, but authorities couldn't find the culprit, so they just referred to him as "Jim the Penman."

But how did he create these forgeries? Ninger bought bond paper and cut it to the same size as U.S. banknotes. He spent weeks working on each bill, first soaking the paper in a solution of water and coffee to simulate the actual texture. Ninger then placed his special paper, still damp, on top of a genuine bank note, put them on a piece of glass and traced the image. To apply colors, he used a camel's hair brush. He imitated the silk threads with red and blue ink and intentionally made the geometric designs inexact. Interestingly, Ninger did not add the words "Bureau of Engraving and Printing" or the warning against counterfeiting. After his arrest, he was asked about the omissions. His response? Because the bureau didn't make them.

From 1882 until his arrest in 1896, he made hundreds of copies, one at a time, never mass-produced. Some even ended up in art collections.

Finally, he was caught by the Secret Service in March 1896. He had paid a New York bartender with a fake $50 note, but the bill got wet on the bar and the ink began to smudge. The bartender reported him. At first, Ninger pleaded not guilty, but then he changed his plea. In May, he was sentenced to six years in prison in Buffalo. It is said that after his release, he forged a couple of British pound notes.

Emanuel Ninger died on July 25, 1924.

ALMA WHITE (1862-1946)

Alma Bridwell White founded the Methodist-based Pentecostal Union Church, first headquartered in Denver, in December 1901. The next year, she wrote *Looking Back from Beulah*, an autobiography, and soon began publishing a journal called the *Pentecostal Union Herald*. The journal was later renamed the *Pillar of Fire*. The name comes from an account in the book of Exodus: "By day the Lord went ahead of them in a pillar of cloud to guide them on their way and by night in a *pillar of fire* to give them light, so that they could travel by day or night. Neither the pillar of cloud by day nor the pillar of fire by night left its place in front of the people."

By 1905, Caroline Garretson, widow of Somerset County farmer Peter Garretson, was in financial straits due to her husband's passing. Carrie, one of her three daughters, had applied for admission to the Pentecostal Union (later Pillar of Fire) Bible School in Denver. In October 1905, Alma and a small delegation had come to New York from Denver, searching for a place to establish a missionary home. Finding nothing suitable in the city, they decided to visit Carrie Garretson at the farm near Weston, New Jersey.

Caroline Garretson was impressed with Alma White's vibrant personality and heartfelt prayers. Seeing this visit as an answer to her prayers, Caroline

Zarephath aerial view. *Author's collection.*

offered to turn over the family farm to the Pentecostal Union for use as a Bible school and missionary training center. The church would assume the mortgages on the farm, which had stood since 1862. These mortgages were finally settled at the camp meeting of 1916.

The next year, about thirty-five children from the church's home in Denver were brought to the farm.

In November 1909, Alma White and her husband led a party of fourteen aboard the *Arabic*, bound for England to set up a missionary headquarters in London. This successful venture led to a long association of the Pillar of Fire in Great Britain.

In 1917, the Pentecostal Union changed its name to the Pillar of Fire, and the next year, Alma White was consecrated as a bishop, becoming the first female to hold that office in any Christian denomination.

At Zarephath, on March 15, 1931, the Pillar of Fire broadcast its first program on AM radio station WAWZ; it later switched to FM and continues to operate.

By 1936, the Pillar of Fire owned property worth an estimated $4 million, and its membership numbered over four thousand in forty-six congregations. On her death in June 1946, Alma White was succeeded as general superintendent by her elder son, Arthur Kent White. Her younger son, Ray Bridwell White, passed away later that year.

Today, the Zarephath community is bordered by the Millstone River and the Delaware and Raritan Canal in Franklin Township, Somerset County, New Jersey. Alma White College closed in 1978, but in 2001, Somerset Christian College was established. Currently known as Pillar College, the school also has a campus in Newark and offers Christian instruction.

CLARA LOUISE MAASS (1876-1901)

The first of eight children born to a young hatmaker and his wife, Clara Maass helped her family by working in the Newark Orphan Asylum at the age of fifteen. When she heard that the Newark German Hospital would train girls to become nurses, at no charge, she signed up. In three years, she proudly received her nursing cap.

Clara volunteered to serve in the Spanish-American War, staying in Jacksonville and Savannah before reaching the camp in Santiago de Cuba. Here she witnessed the horrors of yellow fever and the jaundiced skin of its victims, something she would never forget.

After discharge, Clara volunteered to serve in the Philippines, beginning in 1900. When she became ill, the government sent her home, but she had determined what to do next and volunteered for experiments in Cuba to find the cause of yellow fever. Doctors like Walter Reed and William Gorgas were sure that the disease did not pass from person to person; they thought it was spread by mosquitoes but needed proof.

Clara and twenty others volunteered to be bitten by infected mosquitoes. She contracted a slight case, recovered and offered to be bitten again. This time, she suffered a severe case of yellow fever and died on August 14, 1901. Her sacrifice proved that the mosquito was indeed the carrier of yellow fever. In 1976, on the centennial of her birth, the United States issued a commemorative thirteen-cent stamp honoring Clara Maass.

When the Newark Hospital moved to nearby Belleville in 1952, it became Clara Maass Hospital (now Clara Maass Medical Center), a permanent memorial to a brave young woman from New Jersey.

ALICE PAUL (1885-1977)

Who would have thought that a quiet Quaker girl from South Jersey would one day change the world? When Alice Stokes Paul was born in Mount Laurel, New Jersey, in 1885, only men were allowed to vote in most of the United States. Raised in the Quaker faith, Alice believed in "ordinary equality" for all people. Her religion taught her to try to correct injustice in the world, and she viewed this as a major injustice.

Schooled in England by the fiery suffragists Emmeline and Christabel Pankhurst, Alice was jailed several times and endured forced feeding. She returned to the United States and joined the National American Woman Suffrage Association (NAWSA). At this time, women could vote in some states but not all. The suffragists urged women who already had the vote to elect legislators who favored giving the vote to all women. Alice and many suffragists wanted Congress to pass the Nineteenth Amendment to the Constitution, known as the Susan B. Anthony amendment. This change would allow women to vote in all of the states. But the women had to convince President Woodrow Wilson.

While the eyes of the country were on Washington, D.C., and President Wilson's inauguration in 1913, Alice planned a parade the day before to convince Wilson to give women the vote. She organized twenty-six floats, ten bands, six chariots and eight thousand women to march for voting rights.

Some who were watching the parade attacked the marchers, but newspapers around the country reported news of the march.

Two weeks after the parade, Alice and her colleagues met with President Wilson, asking him to support the Nineteenth Amendment, but he was not interested. The women decided to have more parades and rallies. In 1914, Alice began a new group, the Congressional Union for Woman Suffrage (CUWS). The next year, she formed the Women's International League for Peace and Freedom.

On January 10, 1917, Alice directed her members to picket on the sidewalk in front of the White House. They carried purple, white and gold banners and took turns standing there silently every day except Sundays, day and night, in all seasons and weather. The plan was to picket until President Wilson's second inauguration on March 4, but they stayed longer.

Alice Paul led the fight for women's suffrage. *Courtesy of the Alice Paul Institute, www.alicepaul.org.*

In June, numerous picketers were arrested and sentenced to three days in jail or a twenty-five-dollar fine. All chose jail. Finally, in mid-July, sixteen women were arrested and sentenced to sixty days in the Occoquan Workhouse. This was a horrible place where the prisoners were given food with worms and spoiled meat. They were beaten by guards and forced to stand outside in the cold and rain.

In late October 1917, Alice was sent to the district jail, having written to her mother that it "will merely be a delightful rest." But she knew it wouldn't be. When Alice refused to eat, she was force fed three times a day. In November, a large group of women was sent to Occoquan, where they demanded to be treated as political prisoners, meaning that they could receive mail, visitors and gifts; wear their own clothing; and read books.

Instead, they were dragged and beaten and taken to filthy, dark, damp, cold cells. While there, the women were treated very badly. As a protest, for three weeks Alice went on a hunger strike. To force her to end the strike, the prison guards would not let her have visitors or messages. Still,

she would not eat. To keep her alive, the guards and nurses forced her to eat by tying her down, forcing her mouth open, and pouring liquid food through a tube into her nose. This was very painful and caused her to become quite ill.

In January 1918, a year after the president's second inauguration, Woodrow Wilson changed his mind and supported the women's suffrage amendment.

As her own mother wrote, "Alice at last saw her dream realized."

Following the passage of the Nineteenth Amendment, Alice Paul earned three law degrees (LLB, LLM and DCL). For many years, she lived in Europe, working with the League of Nations to include equality in the UN charter and helped to create the UN Commission on the Status of Women.

Alice went on to author the Equal Rights Amendment, which simply states, "Equality of rights under the law shall not be denied or abridged by the United States or by any state on account of sex." In 1972, both the Senate and the House passed the amendment. During the next ten years, it was approved by only thirty-five of the thirty-eight states needed for ratification. Efforts are underway to again try for ratification. If Congress repeals the time limit of the original bill and three more states vote for ratification, the ERA could become law. For more information on the Equal Rights Amendment, visit www.equalrightsamendment.org.

Alice Paul died on July 9, 1977, in Moorestown, New Jersey, not far from her birthplace at the family home called Paulsdale. She was ninety-two and had fought for equality for her entire life.

Today, her home is the headquarters of the Alice Paul Institute, a center for leadership development programs inspiring young people to make a difference in their schools and communities.

ANNA CASE (1888–1984)

Born in Clinton, New Jersey, Anna Case was an opera singer who sang the role of Sophie in the first American production of the Richard Strauss opera *Der Rosenkavalier* at the Metropolitan Opera House in New York City.

She had debuted as a coloratura soprano at the Met on November 20, 1909, acting the role of a page in Wagner's *Lohengrin*. At that time, she was said to be the only American singer without European training who had been accepted by the Met. She made her last appearance at the Met in the 1919–20 season.

Case recorded with Thomas Alva Edison, who used her voice in "tone tests" to determine whether a live audience could tell the difference between the actual singer and a recording. She recorded on both cylinder and disc records for Edison and later recorded for Victor and Columbia Records. In 1919, she appeared in the silent film *The Hidden Truth*. Case also made a sound film for Vitaphone.

After her retirement, Case gave fifty to sixty concert recitals a year, formally ending her concert career with her marriage in 1931 to Clarence H. Mackay, a music patron.

Anna Case died in New York City at the age of ninety-five. She had two stepchildren, John Mackay and Ellin Mackay Berlin, wife of the composer Irving Berlin. She bequeathed her 167.97-carat Colombian emerald necklace to the Smithsonian Institution.

WALLY SCHIRRA (1923–2007)

Walter "Wally" Schirra of Oradell, New Jersey, was the only astronaut to fly in the Mercury, Gemini and Apollo programs. He was one of NASA's original seven Mercury astronauts. He became the fifth American in space during that program and went on to command Gemini 6, the first rendezvous of two manned, maneuverable spacecraft.

He commanded Apollo 7, the first manned flight in the Apollo program. He and crew members Donn Eisele and Walt Cunningham tested the Apollo systems and proved that the capsule was ready to take astronauts to the moon.

EDWIN "BUZZ" ALDRIN (1930–)

Edwin "Buzz" Aldrin, PhD, was the second person to walk on the moon. Born in Montclair, New Jersey, in 1930, Buzz graduated from Montclair High School and received his bachelor's degree from the U.S. Military Academy at West Point, graduating third in his class. He was awarded his doctorate of science in astronautics from the Massachusetts Institute of Technology for his thesis, "Guidance for Manned Orbital Rendezvous."

Prior to joining NASA, Aldrin had flown sixty-six combat missions in F-86s while on duty in Korea. As a jet fighter pilot, he shot down two MIG 15 aircraft during the Korean War.

His flight in November 1966, with command pilot James Lovell, concluded the successful Gemini program. Lovell and Aldrin guided the Gemini 12 spacecraft on a four-day flight in which Aldrin established a new record for extravehicular activity (EVA) after spending five and a half hours outside the spacecraft.

In the first manned lunar landing mission, Buzz Aldrin served as lunar module pilot for Apollo 11, July 16–24, 1969. He followed Neil Armstrong onto the lunar surface on July 20, 1969, completing a two-and-a-quarter-hour lunar EVA.

In July 1971, Aldrin resigned from NASA, having logged 289 hours and 53 minutes in space, of which 7 hours and 52 minutes were spent in EVA.

Since his retirement, Buzz Aldrin has authored an autobiography, *Return to Earth*, and has remained at the forefront of efforts to ensure a continued leading role for America in manned space exploration to advance his lifelong commitment to venturing outward in space.

In addition, he lectures throughout the world on his unique perspective on America's future in space. He has also authored *Men from Earth*, a book about the Apollo program.

SCIENCE AND SAFETY INVENTIONS

FATHER OF SCUBA DIVING:
CHRISTIAN LAMBERTSEN

Westfield native and Rutgers graduate Christian Lambertsen is known as the father of U.S. combat diving and swimming, according to Tom Hawkins, a historian for the Naval Special Warfare Foundation in Virginia Beach.

As a student at the University of Pennsylvania School of Medicine in 1939, Dr. Lambertsen created a closed-circuit, pure-oxygen rebreather. It allowed carbon dioxide to be scrubbed out through a chemical filter and returned to the diver. As a result, he eliminated the tell-tale bubbles that often gave away a diver's location.

His invention, the Lambertsen Amphibious Respiratory Unit, or LARU, made covert operations possible. Dr. Lambertsen trained the divers (later called SEALs) to use his invention while attaching explosives to Japanese ships or rescuing downed pilots. As an army doctor during World War II, he often led these missions.

The LARU was the precursor to the self-contained underwater breathing apparatus, or SCUBA, a term he is credited with coining.

Dr. Lambertsen's son David said that his father "spent a lot of time on Barnegat Bay with his grandfather collecting clams and started wondering how to go deeper underwater. He had his cousin in a rowboat using a bicycle pump and a hose to pump air fifteen feet down to him."

Christian Lambertsen
invented the first
underwater rebreather,
the LARU. *Courtesy of the
United States Naval History
and Heritage Command.*

APOLLO SPACE SUIT: ABRAM SPANEL (1901–1985)

The Drumthwacket estate in Princeton, now the official residence of New Jersey's governors, was begun in 1835 by Charles Smith Olden. He gave his home the Scots-Gaelic name Drumthwacket, which translates to "wooded hill." Upon his death, Olden left his lands and Drumthwacket to his wife, Phebe Ann Smith.

In 1893, Moses Taylor Pyne (1855–1921) purchased Drumthwacket and began transforming it into a 183-acre estate. In 1921, Moses Taylor Pyne died and bequeathed Drumthwacket to his only grandchild, Agnes.

Abram Nathanial Spanel bought Drumthwacket in 1941. An ingenious inventor, Spanel founded the International Latex Corporation in 1932. It later became the International Playtex Corporation. During World War II, Spanel's company made latex products such as attack boats, life rafts and canteens for the military.

During the war and beyond, Spanel's engineering staff lived at Drumthwacket, conceiving many of his inventions in what today is the Music Room. At his death, Spanel held many patents, including a pneumatic stretcher designed to carry wounded military personnel in the water. He also invented a home hair-cutting device.

In 1965, Abram Spanel's company won a NASA-sponsored competition to develop the Apollo spacesuit. In an address to ILC employees, Spanel remarked, "It is the greatest privilege of my life to present to you the role that your company played in that colossal of all human achievements in placing two American astronauts on the surface of the moon for the glory of civilization and humanity."

Custom-made by ILC employees as a training suit for astronaut Paul Weitz, who flew aboard the Skylab II mission in 1973, the suit is identical to all of the suits that were used on the Apollo 15, 16 and 17 lunar missions.

THE VELOCHAIR™: KENNETH SIMONS

Ken Simons was living a normal, active life until, without warning, he had difficulty standing and walking. After visits to many doctors, he was diagnosed with ossification of the posterior longitudinal ligament (OPLL), a neurological disorder. To keep active outdoors, he began using a tadpole recumbent trike. (A tadpole has two front wheels and one rear wheel.)

The trike, however, was not suitable for indoor activities due to its large size and design. Ken needed a way to get around that would work indoors and outdoors. Many personal mobility chairs were battery operated and folded, but these chairs left the user as a passive rider. Ken needed a vehicle that would help him maintain and strengthen his leg muscles and provide cardiovascular benefit. He decided that he could invent something better.

Working with a manufacturer in Payson, Utah, Ken built a prototype and patented it as the VeloChair™. This invention allows him to sit comfortably and safely and move it by pedaling the chair with his legs. To steer the VeloChair™, Ken uses a lever that makes turning easy, using one or both hands. The steering levers are easily removed to allow transfer in and out of the VeloChair™. He now uses the VeloChair™ to go to business meetings, shop with his wife, attend and participate in family gatherings and watch his grandchildren perform on stage. The VeloChair™ has allowed Ken to safely continue his active lifestyle and stay healthy and exercise his legs.

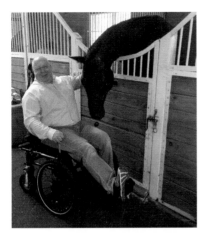

Ken Simons wanted a product that could be moved with just one leg and one arm, no fingers required, and would fold for easy transport, so he created the VeloChair™. *Courtesy of Kenneth Simons.*

The development process of the VeloChair™ required much trial and error to get the turning and forward and back propulsion correct. He wanted a product that could be moved with just one leg and one arm, no fingers required, and would fold for easy transport. Using 3-D printing capability, Ken was able to print parts, test them, change the design and reprint the parts to keep development costs reasonable and find the best way to make the VeloChair™ invention work. Many of the 3-D printed parts were made using carbon fiber, a new 3-D printing process.

Today, the current version of the VeloChair™ has been tested by people challenged with strokes, Parkinson's disease, multiple sclerosis and spinal stenosis who want to remain as active as possible. The VeloChair™ provides a safe way for all these people to fully participate in their lives while getting the benefit of exercising. The VeloChair™ folds for transport, is easy to transfer into and out of, safely allows the user to exercise and is fun. If a person with mobility challenges wants something more than being a passive rider, then the VeloChair™ is a great choice.

3-D SKULL IMPLANT: DR. GAURAV GUPTA

On March 28, 2017, Gaurav Gupta, MD, inserted a skull implant that had been created using 3-D printing. After an injury to his frontal lobe, patient Christopher Cahill experienced life-threatening swelling of the brain, which led Dr. Gupta to perform surgery to relieve the swelling, with the intent to replace the skull afterward. However, Christopher's skull was infected and therefore unusable.

The doctor decided that the best solution to replace the missing skull bone was to use 3-D printing. DepuySynthese, a medical device company, developed a customized cranial skull implant using Christopher's own CT scan. The implant was made of polyetheretherketone (PEEK), a polymer

Dr. Gaurav Gupta inserted a 3-D printed skull implant for patient Christopher Cahill. *Courtesy of the Robert Wood Johnson Medical School.*

chosen for its strength, stability and biocompatibility. The substance PEEK does not cause inflammation and is not rejected by the body.

Although 3-D printing of body parts has been used in recent years, Dr. Gupta points out that "this is not a magic new substance that will increase your life or the fountain of youth. One part, one technology and one technique will not fit all. It has to be custom-tailored to the patient's well-being."

Dr. Gupta is an assistant professor of neurosurgery at Rutgers's Robert Wood Johnson Medical School and the director of cerebrovascular and endovascular neurosurgery at Robert Wood Johnson Medical School and at the University Hospital.

FLUOROPOLYMERS, TEFLON™:
DR. ROY J. PLUNKETT

Sometimes failure leads to a new path. On April 6, 1938, Roy Plunkett was investigating a failed experiment involving refrigeration gases at the DuPont Jackson Laboratory in Deepwater, New Jersey, when he noticed a white, waxy substance. The material proved inert to virtually all chemicals and was the most slippery material ever known. Dubbed PTFE (polytetrafluoroethylene), it was trademarked by DuPont as Teflon™, one of the most valuable and versatile materials ever invented. Teflon™ has contributed to developments in aerospace, communications, electronics, industrial processes and architecture.

On the fiftieth anniversary of Teflon™, Dr. Plunkett said, "I had a good career, a good life. I got to associate with top people. So I can't say I want to do my life over, because I don't know that it would be better if I did."

THE BIG BANG THEORY:
BELL LABS, HOLMDEL, 1965

At Bell Labs in Holmdel, New Jersey, Arno Penzias and Robert Wilson wanted to measure radio signals coming from space. Using the old horn antenna built to detect radio waves bounced off the satellite Echo as a receiver, the scientists quickly noticed something. No matter where they pointed the receiver, they heard a background signal, like static, in the microwave range. After much experimentation, the two scientists

eliminated a number of possible causes: not interference from New York City, a nuclear test or an extraterrestrial signal—not even the pigeons that were living in the antenna.

They then proceeded to examine the work of Edwin Hubble, Albert Einstein, Stephen Hawking and Robert Dicke. The latter knew that they had uncovered the gist of his work on the expanding universe, or big bang, theory. The three men published their work, and in 1978, thirteen years after they had begun their work, Penzias and Wilson were awarded the Nobel Prize in Physics.

BURETTE GLASS TUBE: WILLIAM O. GEYER

A longtime resident of Bloomfield, William O. Geyer began the Scientific Glass Apparatus Company in 1918, only eight years after arriving in the United States from Germany.

He patented many scientific instruments, including the burette, a graduated glass tube with a tap at one end, for delivering known volumes of a liquid, especially in titrations.

His company sold many types of laboratory supplies and glassware.

DRUGS FOR PARKINSON'S DISEASE AND HIGH BLOOD PRESSURE: DR. A. WAYNE RUDDY

During World War II, Dr. Wayne Ruddy worked with a team at Sterling Laboratories of Rensselaer, New York, to discover a chemical synthetic pathway for quinine. This research was urgent, as malaria was killing many U.S. soldiers fighting in the Pacific theater. Sources of natural quinine were in areas held by the Japanese. (Ultimately, a team from Harvard developed synthetic quinine in 1944.)

In the 1950s, Dr. Ruddy became the director of chemical development at Warner-Lambert in Morris Plains. Here he oversaw the successful chemical development of Artane, the first effective drug for Parkinson's disease, and hexamethonium chloride, a drug for the treatment of high blood pressure.

DRUGS TO TREAT TROPICAL DISEASES: WILLIAM CAMPBELL

In 2015, Summit resident William Campbell was awarded the Nobel Prize in Physiology or Medicine for his work in ridding the world of several tropical diseases. Campbell and Japanese scientist Satoshi Omura produced a cure for river blindness and lymphatic filariasis (also called elephantiasis), almost wiping those diseases off the planet.

The drug they produced, ivermectin, attacks the roundworm parasite that causes those two diseases, mainly in the poorest regions of the world. As the Nobel Committee said in announcing the award, "Treatment is so successful that these diseases are on the verge of eradication, which would be a major feat in the medical history of humankind."

Merck eventually made a commitment to donate over one billion treatments to three dozen countries.

Campbell and Omura shared the prize with Chinese researcher Tu Youyou, who won the prize for the development of artemisinin, the top treatment for malaria.

A scientist at Merck from 1957 to 1990, Campbell also created Heartgard, the medicine used to prevent heartworm in pets.

Michael Beachem's lightstick is also sold as glow stick. *Author's collection.*

CYALUME LIGHTSTICK: MICHAEL T. BEACHEM

While working at American Cyanamid in Bridgewater, New Jersey, Michael T. Beachem teamed with Joel Gingras, William Hefferman and Mary-Louise Vega to create the Cyalume® lightstick, also called a glow stick.

A glow stick is a self-contained, short-term light source. It consists of a translucent plastic tube containing isolated substances that, when combined, make light through chemiluminescence, so it does not require an external energy source. The light cannot be turned off and can only be used once. Glow sticks are often used for recreation but may also be relied upon for light during military, police, fire or EMS operations.

The original patent included a container with a hinged lid that opens for display of the lightstick. In this mode, the lightstick and container make a convenient lantern.

NOBEL PRIZE: ADAM GUY RIESS

Dr. Adam Riess, a native of Warren, New Jersey, was awarded the Nobel Prize in Physics in 2011. *Courtesy of Dr. Adam Riess.*

Adam Riess grew up in Warren, New Jersey, attended the New Jersey Governor's School in the Sciences in 1987 and graduated from Watchung Hills Regional High School in 1988. After graduating from MIT, Adam earned his doctorate from Harvard in 1996. His doctoral thesis resulted in measurements of over twenty new type Ia supernovae (exploding stars) and a method to make them into accurate distance indicators by correcting for intervening dust and intrinsic inhomogeneities (a localized collection of matter in the universe).

Dr. Riess worked at the University of California–Berkeley as a member of the High-Z Supernova Search Team. With Saul Perlmutter and Brian Schmidt, he continued his study of supernovae. Here he did the work that resulted in his Nobel Prize, which was awarded for the discovery of the accelerating expansion of the universe through observations of distant supernovae.

Adam Riess moved to the Space Telescope Science Institute in Baltimore, Maryland, in 1999 and has been a professor at Johns Hopkins University since 2005.

TETRACYCLINE AND OTHER ANTIBIOTICS: LLOYD CONOVER

Lloyd Conover developed the chemical process leading to new disease-fighting antibiotics. While working with his team at Pfizer in the 1950s, he discovered that by chemically altering a naturally produced drug, he could create an entirely new antibiotic capable of fighting different diseases. His process has created a wide variety of medicines. Dr. Conover's insight was

that a chemically altered version of a natural antibiotic (like penicillin) might be more powerful than the existing one. To test the theory, he and his colleagues tweaked the structure of aureomycin, another common antibiotic, by replacing a chlorine atom with a hydrogen atom.

He was awarded a patent for tetracycline, one of the most prescribed antibiotics during the 1950s. Tetracycline is used to treat many conditions, ranging from acne and pneumonia to lyme disease.

OIL REFINING TECHNOLOGY: HARTLEY OWEN

Hartley Owen was an inventor and expert in oil refining technology, working for Esso Research and Engineering for ten years and Mobil Research and Development for thirty-one years.

Owen was a world-recognized inventor and expert in the oil industry in refinery process development, fluidized solids and fluid catalytic cracking. He was awarded more than 280 patents, dealing primarily with oil refining technology, chemicals and synthetic fuels. Owen was recognized by Mobil as the inventor with the most patents assigned to Mobil by one inventor and one of the leading patent holders in the U.S. Patent Office. After retiring, he moved to the Eastern Shore of Maryland.

MRI: DR. HERMAN YAGGI CARR

After serving in the Weather Squadron Air Corps in World War II, Dr. Herman Yaggi Carr received his master's and doctorate from Harvard University. In 1952, his doctoral thesis described the first techniques for using gradients in the magnetic field and is believed to be the first example of magnetic resonance imaging (MRI).

Dr. Carr was a member of the Faculty of Arts and Sciences at Rutgers University, where he continued his pioneering research, providing groundwork for the present-day MRI.

DNA RESEARCH: EVELYN M. WITKIN

Evelyn M. Witkin won the 2015 Lasker Award for her research on how DNA repairs itself. For fifty years, she worked at Rutgers, studying how

bacterial cells create an "SOS response" to recognize and overcome damage to their genetic coding. When damage occurs, more than forty dormant genes create an emergency "copier" that can bypass the damaged part of the DNA strand. Without that backup, she pointed out, the DNA would be like a broken zipper that can't get past the damaged section. "That's lethal. The cell would die if it couldn't replicate," she said.

Witkin began her DNA research at Rutgers in 1941, before scientists even knew that genes were made of DNA. In 1971, she moved to Douglass College and then to the Waksman Institute, from which she retired in 1991.

As an interesting sidelight, Evelyn noted that when she was expecting her first child in 1949, she was lucky to have bosses at the university who simply asked what kind of arrangement she needed to make the job work for her. She was able to work part-time because she had a full-time assistant who attended to the day-to-day monitoring of the bacteria while Witkin set up the experiments, analyzed the data and wrote up the results.

HOME OVULATION TEST: HELEN DENISE

How can women determine their most fertile period each month? That was the challenge for Helen Denise, a Paramus resident who faced a life-threatening ectopic pregnancy that caught her by surprise. She wanted to help other women who either wanted to get pregnant or avoid it.

Denise's product, Knowhen®, is not a new test but an easier way to read the test results. It uses the saliva of ovulating women to see the ferning, or crystalline pattern left when the saliva dries. A woman simply dabs a small bit of saliva on the device and, after it dries, examines it through the mini-microscope to see if it has the fern-like pattern. If it does, her fertility is at its peak. The device is sold online and in some pharmacies through Denise's company, HiLin Life Products.

She took her idea to the New Jersey Institute of Technology's Enterprise Development Center in Newark to improve her business plan for Knowhen®.

DEVELOPMENT OF NEW POLYMERS: JOACHIM KOHN

Joachim Kohn, a professor at the Rutgers Department of Chemistry and Chemical Biology, was named a fellow of the National Academy of Inventors, a nonprofit organization comprising over three thousand inventors from more than two hundred institutions.

Kohn, founder of the university's New Jersey Center for Biomaterials, developed tyrosine-derived, resorbable polymers, used in several medical devices. He focuses on new ways to develop biomaterials for applications such as tissue engineering, regenerative medicine and drug delivery. His team discovered a polymer optimized for stents. He holds fifty-eight U.S. patents and received the Thomas Alva Edison Patent Award for best patent in medical technology in New Jersey in 1999 and 2006.

POLYMER TECHNOLOGY: KATHRYN UHRICH

A distinguished polymer chemist, Kathryn Uhrich was the dean of mathematical and physical sciences in the School of Arts and Sciences at Rutgers, developing programs to increase research and teaching collaborations between departments and colleges. Her research focuses on designing bioactive, biodegradable polymers for use in drug delivery, food safety and personal care.

In addition to her position as a fellow of the American Chemical Society, she is editor-in-chief of the *Journal of Bioactive and Compatible Polymers* and a fellow of the National Academy of Inventors of the U.S. Patent and Trademark Office.

She has been issued more than seventy U.S. and international patents, and her work has spawned several start-up companies, including Polymerix Corporation, which created biodegradable delivery systems for nonsteroidal anti-inflammatory drugs and coatings for surgical implants.

At Rutgers, Uhrich championed enhanced STEM education for women and people of color. She worked to ensure inclusive practices for faculty, fostering supportive environments for students, faculty and staff from diverse backgrounds.

In 2016, she was appointed dean of the College of Natural and Agricultural Sciences at the University of California–Riverside.

HELPED BUILD A 3-D HAND: KATHERINE LAU

Katherine Lau, a Rutgers biomedical engineering student, found a great summer project in 2015. She returned home to Las Vegas as part of a team of students who created an affordable, functioning prosthetic hand that can be rebuilt as little Hailey Dawson grows.

Hailey, born with Poland syndrome, a birth defect causing incomplete development of hand and chest muscles, needed functioning fingers. Doctors told her mom, Yong Dawson, that such a prosthesis would cost tens of thousands of dollars and would have to be replaced several times as the child grew. Before spending such a large sum, Mrs. Dawson asked at the nearby University of Nevada–Las Vegas to see if there was an alternative.

Brendan O'Toole, a mechanical engineering professor at the university, saw this problem as an engineering challenge for talented students to gain skills and experience while doing good.

O'Toole chose Katherine to lead a team of three engineering students who would use 3-D printing to create a custom-fitted prosthetic hand for Hailey, a hand that could be rebuilt as the little girl grows. Lau's team knew of designs for 3-D–printed hands, such as Robohand and Enable. But they needed to find a way to adapt these designs to fit Hailey's size and the nature of her deformity.

Working with Hailey throughout the summer, they fashioned a hand with fingers that grasped objects when Hailey bent her wrist forward.

For Katherine Lau, this summer job was a life-changing experience that confirmed she had chosen the right profession.

FIRST SYNTHETIC VITAMIN B-1:
DR. ROBERT WILLIAMS

In the early 1900s, scientists began to realize that "accessory food factors," as Casimir Funk described them, were necessary in small amounts to maintain health. Funk called them "vitamins," a word that contains *vital* and *amine*, a nitrogen-containing group in organic molecules.

Chemists around the world then worked to isolate and synthesize these vitamins. Robert Williams (1886–1965) of Bell Laboratories (who had previously investigated the anti-beriberi factor in the Philippines) asked Merck & Company to help him isolate and produce thiamine, or vitamin B-1. The company designed and conducted clinical trials and provided

a solid grounding for vitamin research. Merck was quickly able to isolate thiamine and test it in humans. In 1936, Williams and a young organic chemist at Merck named Joseph Cline (1908–1989) synthesized the vitamin, beating out competing teams from Germany and England.

RESCUE RELIANCE: DAVE AND PAUL SMART

Dave and Paul Smart are trying to create a gadget that will contain information on every type of vehicle. By seeing on the device's screen all the parts of the car or truck—air bags, batteries, steel frame—emergency responders could more easily operate the Jaws of Life to save lives.

Such a device could become standard equipment for all firehouses and first aid squads. By scanning the vehicle identification number (VIN), a graphic of the interior would appear, showing instant, critical information to rescue and response personnel at the scene of an emergency. It's important for responders to know where the high-voltage batteries are in an electric car and where the air bags are so that workers holding the Jaws of Life aren't suddenly thrown back and injured. The Reliance is designed to meet the needs of fire, paramedic and rescue workers and save lives by instantly showing the locations of airbags, batteries, fuel tanks and more.

The brothers have patented the idea and are using a crowdfunding site to raise the money to construct a prototype. Their website, www.rescuereliance. com, explains how the gadget will work and features videos and testimonials.

DIGITAL SPEECH PROCESSING, GOVERNMENT ACOUSTICAL INVESTIGATOR: JAMES L. FLANAGAN

After graduating from Mississippi State, Jim Flanagan studied communications, acoustics and signal processing at MIT.

Later, at Bell Labs in Murray Hill, New Jersey, Jim continued his research on efficient transmission of speech. In 1965, he published *Speech Analysis, Synthesis and Perception*, which was reprinted four times, translated into Russian and became the foundation for modern speech and audio processing. He later served as a research center director at Rutgers and as the vice-president for research.

Jim will probably be most remembered for his contributions in speech-compression technologies that paved the way for voicemail, internet phone calls, MP3 music files and voice interaction with cell phones.

Additionally, he will be remembered for his acoustic investigations into the JFK assassination, the Apollo I tragedy and the Watergate tapes.

TRU-FIT PROTECTIVE SYSTEM: JOSEPH KRAUSE

Joseph Krause developed the Tru-Fit Protective System to protect his sons during baseball games. *Courtesy of Tru-Fit Protective System.*

Joseph Krause of Old Bridge, New Jersey, has been wearing a hard hat for over twenty-five years, so he's familiar with the problems—bending over causes the hat to fall off, for one. In addition, it's awkward and uncomfortable, he said. With his sons using sports helmets and he and his friends working in the trades, Joseph knew he needed something safer.

In his Tru-Fit Protection System, the hard shell of the hat is designed around a baseball cap. The soft baseball cap slides in and clips on the beak of the helmet. With the help of Velcro® on the back of the cap, the helmet doesn't move at all. He calls it "The Beak That is Unique."

Of his sons who are baseball pitchers, Krause said, "They wear it pitching, they can field ground balls and it doesn't move an inch."

The U.S. Patent and Trademark Office has granted a patent for this design. For more information, visit www.thebeakthatisunique.com.

FATHER OF THE INFORMATION AGE: CLAUDE SHANNON

While working at Bell Labs, Claude Shannon (1916–2001) proposed using the numerals 0 and 1 to formulate and transmit data, a binary breakthrough. These two numerals became the basis for computer language, and Shannon has earned the title of "Father of the Information Age."

DESIGNED "SPEED GUN" AND CATHODE RAY TUBES: P. SAMUEL "DOC" CHRISTALDI

Growing up in Haddonfield, New Jersey, Samuel Christaldi loved to build and operate crystal radio sets. After graduation from Rensselaer Polytechnic Institute, he joined the Allen B. Dumont Laboratories, where he oversaw the design and development of cathode ray tubes, television receivers and military electronic equipment.

Christaldi also assisted in the creation of the radar-based "speed gun," first used to clock pitches in a Brooklyn Dodgers baseball game. He held many patents related to cathode ray tubes and contributed a chapter on oscilloscopes in an industrial electronics handbook. In 1980, he was awarded the Dumont Certificate of Achievement from the Radio Club of America.

SYSTEMS AND METHODS FOR CARBON CAPTURE: RICHARD RIMAN

In October 2014, Rutgers professor Richard Riman was inducted into the New Jersey Inventors Hall of Fame and named "Inventor of the Year."

The Belle Mead resident was honored for his work on systems and methods for carbon capture and sequestration utilizing novel concrete products. He holds patents for the "low-temperature solidification" process. When asked for a simplified explanation of his work, Professor Riman generously wrote the following:

Portland cement is a cement that reacts with water to harden via a process called hydrolysis. When mixed with sand and gravel, we call it concrete. The manufacture of Portland cement creates approximately 1 tonne of CO_2 for every tonne of cement used. Because 4 billion tonnes of CO_2 are used each year, Portland cement is the largest contributor to CO_2 emissions by any single industrial chemical manufacturing process.

My technology is a method of hardening concrete using carbon dioxide instead of water. The hardening process is a chemical reaction where carbon dioxide has a chemical reaction with the cement to crystalize calcite ($CaCO_3$) and silica (SiO_2). Since the carbon dioxide is now a part of the crystal structure of calcite, the carbon dioxide is permanently trapped in the crystal structure and can easily remain there billions of years, if not more.

Thus, this invention makes use of a greenhouse gas (carbon dioxide) not only as a means to make a better cement and hence, concrete (cement, sand, & gravel), but also as a means to reduce greenhouse gas emissions. I will also add that the cement used in my invention is very similar to Portland cement except that it takes less energy to make and also emits less CO2 than Portland cement by about 30%. Thus, the overall reduction in CO2 emissions for the current commercial process can be up to 70%, or reduce CO2 emissions by 2.8 billion tonnes. This is a huge number.

FILTERS, PLASMA ETCHING: ALFRED J. PIERFEDERICI

DEMO of EARLY PUROLATOR FILTER from 1958

Early Purolator filter. *Courtesy of Alfred Pierfederici.*

Alfred J. Pierfederici was awarded over eighty patents in his long career at Purolator, RCA and General Electric. He was born and raised in Raritan, New Jersey, and graduated from Somerville High School in 1946. He graduated from DeVry Technical Institute and attended Rutgers at night for nine years.

Around 1954, after seeing vandals break off the antennas on cars, he decided to make a molded plastic antenna that could not be broken. Today's cars now have the molded antennas.

In the 1950s, while working for Purolator in Rahway, New Jersey, Pierfederici developed improved filters for air, oil, fuel and water. In addition, he created the type of carbon paper needed for filtration.

One specific Purolator patent was the variable density air purifier panel, a panel-type filter for removing contaminants such as dirt and dust from air and other gaseous fluids. It provided a novel-type filter for use in air conditioning units, ventilating systems and heating units for removing dirt and dust from a moving stream of air.

As a plasma engineer at RCA and at General Electric, he invented a plasma etching device with a quartz cylinder surrounded by radio frequency–energized coils. It contains a slotted aluminum tube into which the wafers for etching are processed. Each slot has a shield to intercept

optical radiation, including UV, of the plasma from entering the tube, but still permitting the active etching substance to pass into the tube to act on the wafers. Later, he developed larger versions of these etching devices and became an expert in the field.

JOHNSON & JOHNSON FIRSTS

1887 First mass-produced sterile surgical dressing and sterile sutures

1888 Johnson & Johnson pioneers the first commercial first aid kits. The initial kits are designed to help railroad workers, but soon become the standard for treating injuries.

1896–97 Employees manufacture the first mass-produced sanitary protection products for women, a huge step forward in women's health.

1898 The company is the first to mass produce dental floss to make it affordable so that people can take better care of their teeth. The floss is originally made from leftover suture silk.

1921 BAND-AID® Brand Adhesive Bandages, invented by employee Earle Dickson in 1920, go on the market. They are the first commercial dressings for small wounds that consumers can apply themselves.

1954 JOHNSON'S® Baby Shampoo with NO MORE TEARS® formula enters the market as the first mild and soap-free shampoo designed to be gentle enough to clean babies' hair but not irritate their eyes.

1987 The vision care business introduces ACUVUE® Brand Contact Lenses, the first disposable contact lenses, which can be worn for up to a week, thrown away and replaced with a fresh pair.

1994 The PALMAZ-SCHATZ® stent, the first coronary stent, revolutionizes cardiology. Coronary stents keep vessels open so blood can flow to the heart. Later, Cordis Corporation introduces the first drug-eluting stent, which helps prevent the arteries from re-clogging.

HOME IMPROVEMENTS

MOSQUITO TRAP: THE "TRAPOSQUITOES," NEW JERSEY EIGHTH-GRADERS

Layaly Saleh, Karen Ayoub and Karen Mateo—the Traposquitoes—from Public School 28 in Jersey City have built a better mosquito trap.

Knowing that mosquitoes can transmit malaria and the Zika virus, these eighth-graders decided to build a trap that is environmentally friendly and still effective. Instead of using electricity, this invention uses compost and a solar panel to essentially trick a mosquito into thinking the trap is a human. A fan then sucks the mosquito into the trap and down into the compost. The girls said their trap, which has about a twenty-foot range, is a less harmful approach for the environment.

Traposquitoes. *Courtesy of Karen Ayoub, Traposquitoes.*

In the summer of 2016, the students set up the new trap at the Jersey City Reservoir No. 3 for a demonstration to the press and to educators taking part in the Honeywell Institute for Ecosystems Education (HIEE). For all of their

efforts, the Traposquitoes were awarded the Presidential Environmental Youth Award (PEYA) in 2017.

This Traposquito is only one of many prototypes that the group has built. To check the more current models, one can visit their Twitter, Facebook and websites listed below. The Global Traposquito is even being built in the U.S. Virgin Islands at the Julius E. Sprauve School. The girls have posted a tutorial on how to build it on YouTube.

Twitter: @traposquitoes
Facebook: Trapping Mosquitoes
Instagram: @traposquitoes
Website: http://traposquitoes.wixsite.com/traposquitoes

HOME HEATING SYSTEM THAT LED TO THE THERMOSTAT AND FORCED AIR FURNACES: ALICE PARKER

Alice Parker's story is both fascinating and mysterious. How does a young African American girl from Morristown, New Jersey, transform the home heating industry? And then how does she vanish from history?

In 1919, Alice, who had taken classes at Howard University, received a patent for her design of a "new and improved heating furnace" that used natural gas. Apparently, no one before her had thought of using natural gas as a fuel.

It should be noted, however, that Alice did not invent the gas furnace. Her gas furnace design was eligible for a patent because it used independently controlled units that allowed the user to control the amount of heat in different areas of a building. This was similar to today's zone systems.

TIPPY BOTTLE STABILIZER: JASON FREIDENFELDS

While Jason Freidenfelds was in elementary school in Madison, New Jersey, he learned about an Invention Convention contest sponsored by the Silver Burdett Ginn publishing house.

Jason was trying to think of a useful item to invent and then he remembered something:

Fourth-grader Jason Freidenfelds invented the Tippy Bottle Stabilizer. *Courtesy of Jason Freidenfelds.*

At the dinner table one night I noticed we always tipped our salad dressing bottles upside down to get the last of the dressing out, and inevitably they'd get knocked over. So I thought it would be great to have something that just held the bottles up, since no doubt other families were doing the same thing. (I later found out restaurants do this with their ketchup bottles, too.) At first I drew up some contraptions involving a larger structure, something like guy-lines holding up a tower. But it was easier to just make a block that would hold the bottle in place by the neck. So my dad (John Freidenfelds) helped me with a jigsaw and drill in our basement to cut out a block, and there was the prototype! Simple, but it held up the bottle.

Participation in this contest was driven by Aldona Skrypa, a brilliant teacher who went out of her way to bring enrichment programs to her kids, particularly in science. She taught 3rd grade at Torey J. Sabatini School in Madison when I was there, and I believe I was in the 4th grade when this contest came around. She was piloting the program and suggested I give it a try. (Lucky first shot!) She's received a number of awards over the years for her innovative work in education. Really an amazing influence.

And yes, Jason holds patent D307225, awarded in April 1990.

PAPER PUNCH: CHARLES BROOKS

A resident of Newark, Charles Brooks patented the paper punch in 1893. It was originally used to punch tickets (theater or trolley tickets, perhaps). To avoid having the punched-out holes fall on the floor, Brooks included a built-in receptacle to collect the round pieces of waste paper.

TALCUM POWDER: JULIUS FEHR

Born in Germany, Julius Fehr came to the United States in the 1850s. He worked as a druggist in Hoboken to support himself while attending the College of Physicians and Surgeons at Columbia University.

Dr. Fehr experimented with magnesium silicate (talc) and received patents in 1873 and 1875. The first was awarded for his "new and improved Medical Compound," capable of being "altered as dictated by the nature and complaint of the user." The second patent was needed because of formula changes and improvements. This new powder, he said, could now be used for chafing, scalds and burns; as baby powder or tooth powder; and for drying ladies' hair.

An advertisement for Fehr's talcum powder. *Courtesy of Maureen Wlodarczyk, from her book,* Jersey! Then…Again.

BRASSIERES THAT CONFORMED TO WOMEN'S BODY SHAPES: IDA COHEN ROSENTHAL, COFOUNDER OF MAIDENFORM

Ida Cohen Rosenthal (1886–1973) and her husband, William, came to the United States from Russia in 1905. After opening a dress shop in Hoboken, they began designing bras that conformed to women's body shapes. Women quickly responded to this innovation, and the Rosenthals founded the Maidenform Brassiere Company (later changed to Maidenform) in Bayonne. The company thrived there for most of the twentieth century before moving to Iselin in 2007. Maidenform is a world leader in sales of women's intimate apparel.

SPRINGSHIELDS®: DEAN MARELLI

If you have an in-ground pool, you may have experienced the problem of the spring covers, which hold the cover on, falling off while you are opening and closing the pool in spring and fall. These are just standard tubes that fall off. The unprotected springs may rip the cover, scratch the decking, rip your liner or just fall off.

The advantage of the SpringShield® is that it doesn't fall off. The patented SpringShields® are made to snap on and stay on so that the homeowner or pool contractor doesn't have to go through the redundancy of replacing the spring covers two times a season. They can be installed on new covers or existing in-ground pool covers. SpringShields® are produced with a very flexible material so that they fit many different springs. For more information, visit SpringShields.com.

PAAS EASTER EGG DYE: WILLIAM TOWNLEY

The famous Easter egg dye used by many American families had its start in a pharmacy in Newark. Around 1880, druggist William Townley spilled some aniline powder on his suit while serving a customer. This mishap gave him the idea of selling the powder in paper packets, and a new product was born.

His creation, which he named PAAS (a Dutch word for Easter), was made in a Newark factory for over eighty years. Then, in 1959, the firm

The SpringShield. *Courtesy of Dean Marelli.*

PAAS Easter egg dye. *Courtesy of David and Jan Wiley.*

was bought by Abe Plough, whose company became Schering-Plough. Now PAAS colors are made by Signature Brands, based in Ocala, Florida.

Son Stephen Townley took over in 1894, creating the familiar tablets that dissolve in water and vinegar. He developed new colors and designs showing patriotic figures and cartoon characters. During World War II, when the government banned chocolate molded candy (think Easter bunnies), PAAS sales spiked. If people couldn't have chocolate rabbits, then they would color more eggs.

SINGER SEWING MACHINE IMPROVEMENTS: ISAAC SINGER

Isaac Singer did not invent the sewing machine. That honor goes to Barthelemy Thimonnier, a French inventor; Walter Hunt, a mechanic from New York State; and Elias Howe. Howe, of course, received a U.S. patent on his sewing machine. He then moved to England, where he sold the rights for £250. Returning home, he found that sewing machines were being widely manufactured and sold in the United States in violation of his patent. After much litigation, his rights were finally established in 1854, and from then until 1867, when his patent expired, he received royalties on all sewing machines produced in the United States.

In 1850, Isaac M. Singer also invented a sewing machine, one that had a presser foot, allowing it to operate at nine hundred stitches per minute. He had been repairing another machine and then designed a better one. His model used a suspended arm, placed a horizontal bar around the needle and was the first one that could sew continuously, even in curves.

Seven years later, he partnered with Edward Clark to found the I.M. Singer Company. Within three years, Singer was the largest sewing machine manufacturer in the world, with its headquarters in Elizabeth, New Jersey.

BIBLIOGRAPHY

"America Between the Wars." U.S. Army Signal Corps, http://www.armysignalocs.com/veteranssalultes/pt4_radar.html.

"Beer Can History." Brewery Collectibles Club of America, http://www.bcca.com/beer-can-history.

Bergmann, Randy. "Ten Things N.J. Does Better than Other States." *Asbury Park Press*, August 14, 2011.

Bond, Gordon. "How Thomas Mundy Peterson Made the Most of His Historic Vote." June 26, 2017, lecture, Historical Association of Woodbridge Township, New Jersey.

"Branch Brook Park." Essex County Department of Parks, Recreation and Cultural Affairs. https://www.essexcountyparks.org/parks/branch-brook-park/about.

Branchburg News. "'Draft Top' Invention May Be a Game-Changer for Beverage Lovers." October 2015.

"Buzz Aldrin." NASA, https://www.jsc.nasa.gov/Bios/htmlbios/aldrin-b.html.

Carl, Fred. Tour of the InfoAge Museum, Wall, New Jersey.

"Communications Satellite, SCORE." Smithsonian. https://airandspace.si.edu/collection-objects/communications-satellite-score.

Coughlin, Kevin. "Bet You Didn't Know…Morristown at 150, Brought to You by the Library." *Morristown Green*, September 18, 2015. https://morristowngreen.com/2015/09/18/bet-you-didnt-know-morristown-at-150-brought-to-you-by-the-library.

Courier-News. "A More Colorful Cranberry." November 26, 2015.

———. "A Rutgers Professor Emeritus and Millstone Resident Credited with Saving the U.S. Dogwood Industry Has Been Inducted into the New Jersey Inventors Hall of Fame." November 9, 2012.

———. "Rutgers Scientist Honored for Inventive Ways." November 9, 2014.

Cunningham, John. *Newark.* Newark: New Jersey Historical Society, 1966.

———. *The New Jersey Sampler.* Florham Park, NJ: Afton Publishing Company, 1977.

Darragh, Tim. "N.J. Inventor Creates Home Test to Take Mystery Out of Ovulation." *Star-Ledger*, March 12, 2015.

Debold, John. "Those Scientific Geyers." *New Town Crier* (Historical Society of Bloomfield newsletter), March 2016.

"Dorcas Reilly." Drexel University, http://drexel.edu/alumni/connected/alumni-spotlight/1940s/reilly.

"Dr. Roy J. Plunkett: Discoverer of Fluoropolymers." Fluoropolymers Division Newsletter, Summer 1994.

Ehlenfeldt, Mark, and Albert Morison. "The Cooney Bluebird Tractor." Whitesbog Preservation Trust newsletter (Second Quarter, 2015).

Falzon, Francesca. "Retired Rutgers Professor and Genetics Pioneer Wins Prestigious Award." *Rutgers Daily Targum*, September 16, 2015.

"Francis Hopkinson." Flag of the United States of America. http://www.usflag.org/history/francishopkinson.html.

"Francis Hopkinson: 1737–1791." Signers of the Declaration of Independence. http://www.ushistory.org/declaration/signers/hopkinson.html.

"Francis Hopkinson: 1737–1791, Signer of the Declaration of Independence." Crossroads of the American Revolution. http://revolutionarynj.org/rev-neighbors/francis-hopkinson.

Friends of Twin Lights. twinlightslighthouse.com.

"Global Recognition for Groundbreaking Discovery." Bell Labs, https://www.bell-labs.com/our-people/recognition.

Hall, Jen. "How Rutgers Revitalized an Industry." *Edible Jersey*, July 6, 2017, http://ediblejersey.ediblecommunities.com/food-thought/how-rutgers-revitalized-industry.

Hevesi, Dennis. "Christian Lambertsen, Inventor of Scuba Precursor, Dies at 93." *New York Times*, February 25, 2011.

"John Fitch's Steamboat Historical Marker." Explore PA History, http://explorepahistory.com/hmarker.php?markerId=1-A-394.

Johnson, James P. *New Jersey: History of Ingenuity and Industry.* Northridge, CA: Windsor Publications, 1987.

Kuhl, Henry. Kuhl Corporation, Flemington, New Jersey, interview with the author.

"Lewis D. Bunn." Find a Grave, November 5, 2013, http://www.findagrave.com/cgi-bin/fg.cgi?page=gr&GRid=119856301.

Lowe, Peggy. "Green Bean Casserole: The Thanksgiving Staple We Love—Or Loathe." NPR, November 24, 2015, http://www.npr.org/sections/thesalt/2015/11/24/456237098/green-bean-casserole-the-thanksgiving-staple-we-love-or-loathe.

Mazzola, Jessica. "N.J. Couple's New Product Idea: A 'Toilet Seat Belt'." *Star-Ledger*, December 14, 2014.

Melisurgo, Len. "More Accurate Storm Predictions Unlocked." *Star-Ledger*, March 9, 2016.

Mota, Caitlin. "These N.J. Girls Are Developing a Plan to Limit Mosquitoes in an Eco-Friendly Way." *Jersey Journal*, August 16, 2016.

O'Brien, Kathleen. "Plant Profs Produce Pumpkin Pepper." *Star-Ledger*, April 25, 2017.

———. "Rutgers Geneticist Wins Prestigious Award for DNA Work Begun in 1941." *Star-Ledger*, September 9, 2015.

———. "Scientist from N.J. Shares in Nobel Prize." *Star-Ledger*, October 6, 2015.

———. "23 Products Still Made in New Jersey." *Star-Ledger*, June 7, 2017.

O'Neill, James M. "The Rare Wildflower that Only Blooms in New Jersey." *Courier-News*, May 28, 2017.

Peet, Judy. "Images Changed Our View of Space." *Star-Ledger*, April 1, 2010.

Percheron Park, Moorestown, New Jersey. PercheronPark.org.

Polanin, Nicholas. "New Jersey Eighth-Graders Build a Better Mosquito Trap." *Star-Ledger*, June 28, 2017.

Portlock, Sarah. "How This Cube Could Topple the Cell Tower." *Star-Ledger*, March 2, 2011.

Rejan, Wendy A. *Fort Monmouth.* Charleston, SC: Arcadia Publishing, 2009.

"The 'Rutgers 250' Tomato and the Original 'Rutgers' Tomato." Rutgers, http://njfarmfresh.rutgers.edu/whatabouttherutgerstomato.htm.

Scientific American. "Edison's System of Concrete Houses." November 16, 1907.

Star-Ledger. "'Doc' Christaldi, 93, Innovator in Radar." July 5, 2008.

———. "Dr. A. Wayne Ruddy." August 22, 2011.

———. "Herman Yaggi Carr, Professor, Researcher." April 11, 2008.

"The Telephones of Thomas Edison." Bob's Old Phones. http://www.telephonecollecting.org/Bobs%20phones/Pages/Essays/Edison/Edison.htm.

Thomas A. Edison Papers, Rutgers School of Arts and Sciences. edison.rutgers.edu.

Thomas, J.D. "The Colonies' First and New Jersey's Only Indian Reservation." Accessible Archives, August 29, 2013, http://www.accessible-archives.com/2013/08/colonies-first-new-jerseys-indian-reservation.

Times Record. "My Eastern Shore." July 17, 2011.

U.S. Army CECOM Life Cycle Management Command. "A Concise History of Fort Monmouth, New Jersey, and the U.S. Army CECOM Life Cycle Management Command." http://www.fortmonmouthnj.com/wp-content/uploads/2014/12/Concise-History-of-Fort-Monmouth.pdf

White, Linda Foulke. "Foulke Discovers First Dinosaur in America." *Foulke Family Herald* (November 1991), http://www.foulke.org/history/essays/dinosaur.shtml.

Wlodarczyk, Maureen. "Julius Fehr, Doctor and Inventor." Garden State Legacy.

Ziobro, Melissa. Specialist Professor of Public History, Department of History and Anthropology. Interview with the author.

INDEX

ABOUT THE AUTHOR

Linda Barth has been a fan of New Jersey for a long time. A lifelong resident of the Garden State, she became fascinated by the many inventions created here. After the publication of *A History of Inventing in the Garden State: From Thomas Edison to the Ice Cream Cone* (The History Press, 2013), many people told her of additional New Jersey inventions. These new creations led to this current book. With her husband, Bob, Linda Barth has written *The Millstone Valley Through Time* and *Somerville Through Time*. She has authored three books about the Delaware and Raritan Canal as well as *Hidden New Jersey*, a seek-and-search book.

Visit us at
www.historypress.com